Esquire
DRESS CODE

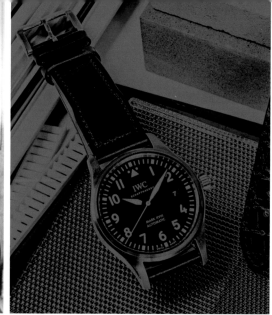

Esquire

DRESS CODE

A MAN'S GUIDE TO PERSONAL STYLE

HEARST
books

Jon Hamm

CONTENTS

For a long time, having your own style was like knowing your business model—it was something you could lock in once, only occasionally having to adjust, depending on small evolutions in the market of trends and your age. In other words, you were pretty well set. You could find your style at twenty-two and—apart from suffering a midlife crack up at fifty-seven that left you wearing a burlap onesie and eating hay on an ashram in Tennessee—you would probably stay in that style-lane (minus the 80s bolo tie, plus the Casentino top coat, if you're me) most of your life.

No more, dude. No more.

These days, one's style, just like one's business model, seems to get "disrupted" at every change in the weather. New micro-trends emerge from far-flung corners of the digiverse. New sneakers drop, new designers and their visions suddenly dominate the conversation, new guys with original and influential looks emerge, and the new way we live sometimes requires a total wardrobe change. Thanks to the pace of it all, which is faster than ever, not only can you participate in it, you don't really have a choice. Because if you don't, well, your look will go the way of your disrupted business model: extinction.

Extinction does not help you feel good in the morning when you look in the mirror.

Yet, let me pause to confess something unavoidable. After twenty years as a magazine editor, I sometimes feel a little style fatigued. But that's just normal, with all that I described above going on. Also, this applies: not just some of the former rules of dressing well have been rescinded, but all of them. It's a moment when we all need help.

So, away with the old rules, and in with the new code—our approach to style that doesn't prescribe one way for all men to dress and will help you find the right clothes for the right moment. After all, we have different body types, sensibilities, jobs, ambitions, and we all live in different places. What connects us if you're an *Esquire* reader, is a mutual admiration for intelligence, originality, quality, honest advice, and taste.

What you hold in your hands is part look book, part service manual, and it's here to inspire you. It's not here to tell you that there's only one way to get it right, but we do have a few things we want to make sure you don't get wrong. There are more than a few secrets in the style world that we want to share with you. Because that's the kind of guys we are, here at *Esquire*. That's also part of our code.

JAY FIELDEN

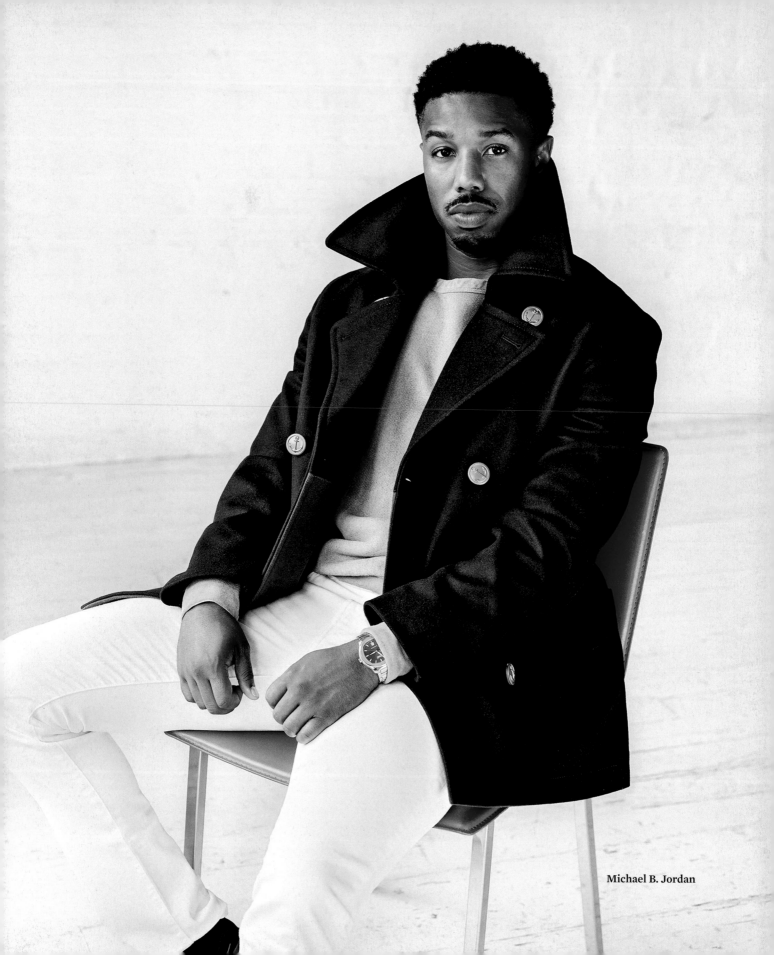

Michael B. Jordan

THE BASICS

THE FOUNDATION OF EVERY GREAT WARDROBE

"Being **PERFECTLY WELL-DRESSED** gives one a **TRANQUILITY** that no religion can bestow."

—RALPH WALDO EMERSON

For those who care only about the latest trends, dressing can be a bit of a merry-go-round. First it's in, then it's out, then it's in again. But for those who care about style, putting together a great wardrobe is more of a one-and-done exercise. Because while fashions fade (and often quickly), great style lasts forever. And the pillar of great style is a wardrobe that begins with the basics—items that will work with just about anything in your closet and that look great in any era. Think of it as a foundation on which you will build your entire sartorial identity. And, just like in a house, a good foundation is what will keep everything from tumbling down—that is, from making you look bad in old photos.

CLOSET ESSENTIALS

THE SIX THINGS THAT EVERY MAN SHOULD OWN

When it comes to building a great wardrobe, it's important to start with the staples. These are the tried-and-true essentials that will ensure you not only have a well-rounded closet, but that you'll also never have to face the soul-crushing problem of not being able to find something to wear. They'll serve as the foundation for your entire wardrobe, and, should you want to get a little daring with something more fashion-forward, they'll help round out your look so that you don't end up coming off like a cartoon character.

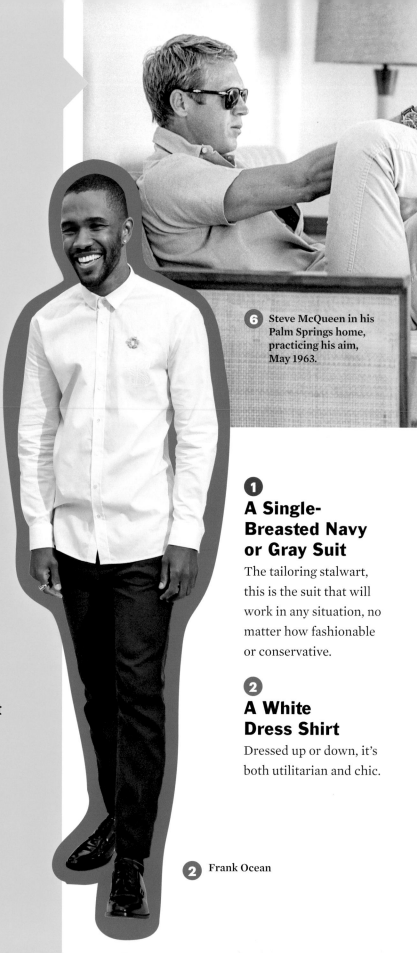

6 Steve McQueen in his Palm Springs home, practicing his aim, May 1963.

1

A Single-Breasted Navy or Gray Suit

The tailoring stalwart, this is the suit that will work in any situation, no matter how fashionable or conservative.

2

A White Dress Shirt

Dressed up or down, it's both utilitarian and chic.

2 Frank Ocean

3 Alden Ehrenreich

1 Kit Harington

5

4

3

Crew-Neck Sweater

Can be worn on its own, over any shirt, or under any suit or blazer.

4

A Great Pair of Jeans (Better Yet, Two)

Dark indigo jeans to dress up; worn-in blue jeans to go casual.

5

Oxford Dress Shoes

The perfect shoe for any dressy occasion.

6

White Sneakers

Classic or minimalist, they're the ultimate in casual style and utility.

THE
CLASSICS

TIMELESS STAPLES THAT NEVER NEED AN UPDATE

You've got the essentials covered. Now it's time to add a few classics to your wardrobe for that dash of sophistication and timelessness. Not only will these simple, quintessential styles add both longevity and versatility to your look, they will also buffer you against the changing whims of fashion. Because, while trends come and go, classic clothes are forever. Think of these as your wardrobe stalwarts—a lineup of always-stylish pieces that you can use to dress up, dress down, or anything in between.

Khakis

While jeans have long been the go-to for casual dressing, khakis—also known as chinos—have, for nearly as long, been the preppier, sportier alternative. Just think of John F. Kennedy on his yacht in a pair for that exemplary image of casual, some might even say slightly rumpled, elegance. Pair them with white sneakers and a crew-neck sweatshirt for a weekend look, or spruce them up with black loafers and a white Oxford shirt for something a little more sophisticated

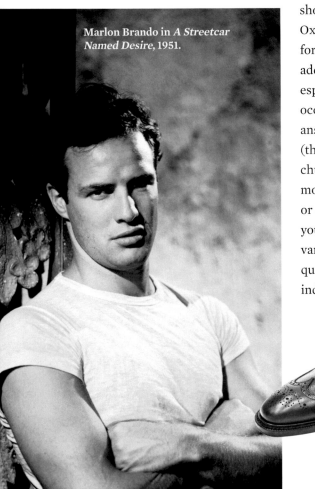

Marlon Brando in *A Streetcar Named Desire*, 1951.

A White Tee

Marlon Brando, Steve McQueen, James Dean—throw on a simple white T-shirt and you're guaranteed to be in good company. It's an all-American standard that you'll likely find a million uses for. Wear it classic rebel style with a pair of blue jeans, or under a cardigan for some easy layering. You can even throw a blazer over it for a night out on the town.

Brogues

If you only have one pair of dress shoes, it's best to stick with Oxfords, since they're the most formal. If, however, you want to add some variety to your footwear, especially for slightly less dressy occasions, leather brogues are the answer. Thanks to the broguing (the holes), they're a little bit chunkier and work better with more casual looks—think jeans or chinos. It's a classic shoe that you'll be able to wear for a wider variety of occasions, which will quickly make them your most indispensable pair.

A Navy Blazer

Worn preppy, sophisticated, or casual, the navy blazer is about as utilitarian a piece of tailoring as you're ever going to find. It's a menswear staple that has stood the test of time largely because of its versatility. Dress it up for cocktail hour with dark trousers and a white dress shirt, or dress it down for date night with a T-shirt and jeans. Or, feel free to mix in some boarding-school prep with a light blue Oxford. The only question left is this: gold buttons or blue?

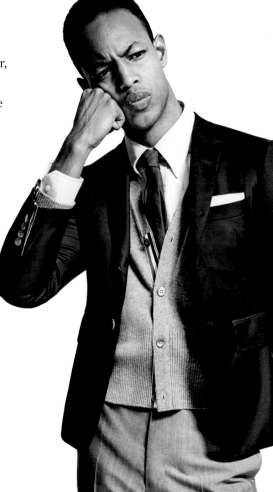

A Trench Coat

Technical rainwear may be a
marvel of modern weatherproofing,
but it often falls short in the
style department. Barring a daily
commute that involves trekking
through the Andes, a more
sophisticated option is a must. The
smartest choice is the classic trench
coat. Originally designed for British
soldiers fighting in the trenches of
World War I, it's plenty stout when
it comes to waterproofing. And,
thanks to a century on the backs of
some of the most dapper dressers
around, it has more than enough
style chops to match.

A White or Blue Oxford Shirt

Tucked into a pair of jeans or worn
under a blazer, it's tough to find a
dress shirt with more versatility
than a white or light blue Oxford.
Basically it's the white T-shirt of the
shirt world—a wardrobe workhorse
that can be dressed up or dressed
down to suit nearly any nonformal
occasion. It'll also look great with
a knit tie, so it's perfect for the
office. If you could have only one
desert island shirt in your closet,
the classic Oxford would be the
way to go.

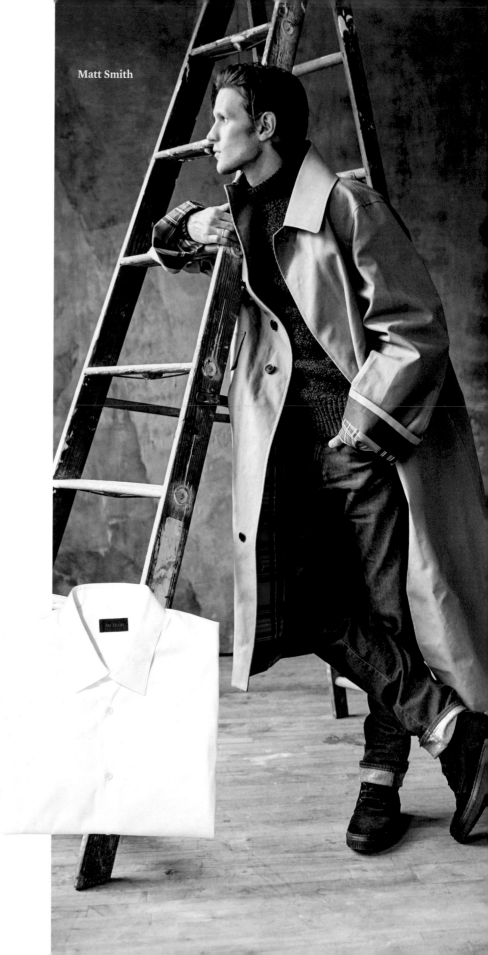

Matt Smith

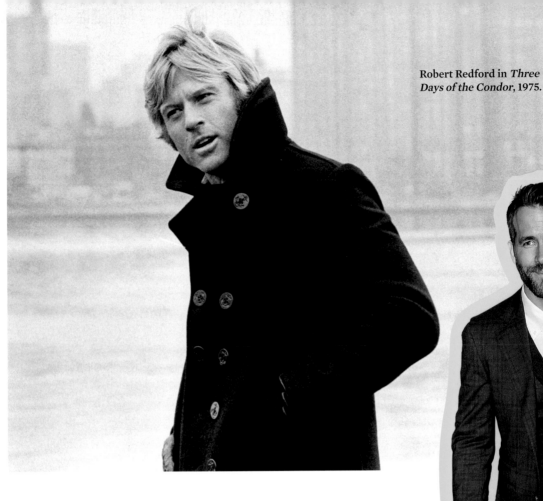

Robert Redford in *Three Days of the Condor*, 1975.

A Peacoat

When the harsh chill of winter sets in, it's important to have a coat that will protect you from the elements. And one of the most stylish ways to do that is with a navy peacoat. If you want to see the sartorial bona fides of this classic coat, look no further than Robert Redford in *Three Days of the Condor*. With his navy surplus peacoat collar popped, it's hard to imagine a hunted CIA spy who's ever had more rakish allure. And, given its provenance as winter gear for North Atlantic sailors, it's pretty much guaranteed to keep you warm even on the coldest days.

A Cardigan

From Mr. Rogers to Thom Browne to Kurt Cobain, there's no shortage of evidence that a great cardigan can be an incredibly versatile piece of knitwear. Whether you wear it with a suit and tie for a cold-weather formal look, or with a T-shirt and chinos for something more casual, a cardigan is always a great way to add both sophistication and texture to your outfit. Plus, they're comfortable. One point to remember: while a chunky cardigan will look great on its own, a thinner cardigan is the better choice for layering.

Ryan Reynolds

CLASSIC PAIRINGS

FOUR LOOKS THAT WERE BORN TO GO TOGETHER

1
Navy Blazer
+
Light Blue Oxford Shirt

2
Khakis
+
Black Leather Loafers

3
Seersucker Suit
+
Suede Derbies

4
White T-Shirt
+
Blue Jeans

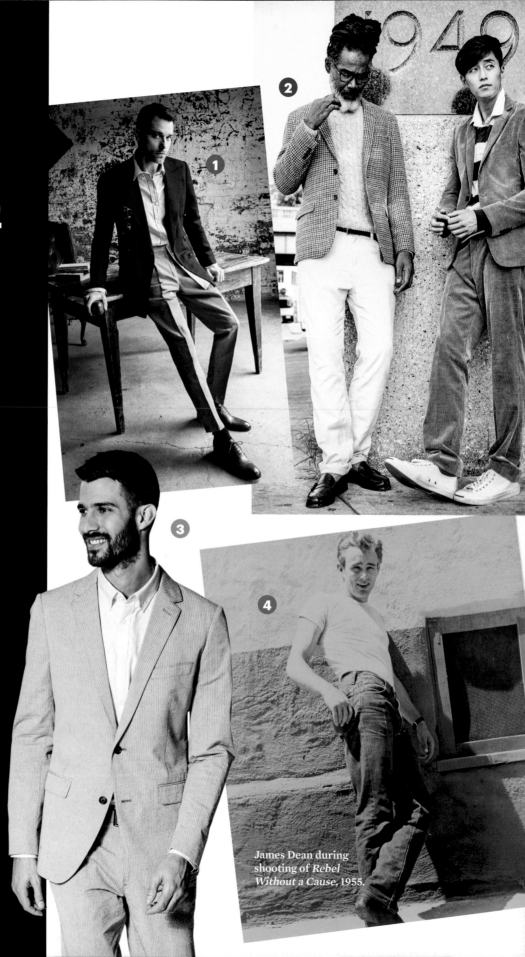

James Dean during shooting of *Rebel Without a Cause*, 1955.

Wear a Blue Blazer

In terms of utility, it's hard to beat a blue blazer. Need proof? Here are three ways to wear one.

Classic

Pair it with chinos or trousers and a classic Oxford shirt for a button-down look.

Middle of the Road

For something less buttoned up, mix it up with jeans and a crew-neck sweater or tee.

Fashion Forward

This one is tricky to pull off, but with shorts, a dress shirt, and a tie (and a bold print to boot), it'll show them you've got game.

Ralph Lauren

Pharrell Williams

Colin Farrell

Liev Schreiber

STYLISH IN ANY ERA

The great benefit of classic menswear is that it will always stand the test of time. After all, as legendary French couturier Yves Saint Laurent once said, "Fashion fades, style is eternal." For proof of this, look no further than these five classic menswear stalwarts. If you're afraid that wearing the latest oversized hoodie or space-age sneakers will one day make you look like dad in his polyester leisure suit, turn to these forever-stylish pieces instead.

Gray Crew-Neck Sweater

John F. Kennedy

Converse Chuck Taylor All-Stars

Converse Chuck Taylor All-Stars

A brown rubber sole, a white rubber toe cap, and a canvas upper. This formula has remained intact since the American basketball player Charles "Chuck" Taylor first invented the Converse All-Star back in 1923. By the 1940s, the sneaker's popularity had spread well beyond the basketball court. And, thanks to its beloved status among everyone from preppies to punk rockers, those style bona fides have only increased over the intervening 80 years.

Gray Crew-Neck Sweater

First invented in 1920 by a University of Alabama football player, the simple gray crew-neck sweater quickly became a favorite among college students across the country. Since then, its dialed-down collegiate style has helped make it a mainstay of off-duty wardrobes everywhere. Whether you prep it up with a pair of classic chinos or go full Americana with a pair of beat-up 501s, it's one of the most versatile layers in any man's wardrobe.

The Fisherman's Sweater

Also known as the Aran sweater—named after the small set of islands off the west coast of Ireland where the sweater originated—this cable-knit classic has been keeping maritime types warm for nearly 100 years. And along the way, it's also become a menswear staple thanks to style icons like Ernest Hemingway and Steve McQueen. As durable as it is stylish and comfortable, the fisherman's sweater is a winter heavyweight, both literally and figuratively.

Levi's 501s

Invented by Levi Strauss in 1873 as a durable work pant, the 501 has since become a cultural institution. Just about as iconic a piece of sartorial Americana as you can get, these simple, straight-leg denim jeans have been a favorite of everyone from presidents to rock stars. Whether you prefer them new and dark or old and faded, it's impossible to beat the classic, laid-back appeal of this denim masterpiece.

Breton-Striped Tee

Though it originated as a uniform for French sailors during the 19th century, it was during the early 20th century that the Breton stripe really took flight. This was due in large part to its popularity among artists and bohemians, Pablo Picasso being one of the most prominent. Since then, it has further anchored itself into the menswear canon courtesy of style icons as varied as Cary Grant and Kurt Cobain. For a dash of bohemian flare, look no further than the Breton-striped tee.

Levi's 501s

Kurt Cobain

Breton-Striped Tee

INVESTMENT PIECES

WORTH THE PRICE OF ADMISSION

Today it's become so easy to buy inexpensive clothes that we tend to forget there are some things you really should spend money on. Not that anyone loves emptying their bank account for the sake of their closet. It's just that, when you buy something that's both well-made and timeless, it ends up being a much smarter way to spend your money. These are the types of things that, whether you wear them frequently or not, will be around for a long, *long* time to come. So, in financial terms, your wardrobe ROI will be much higher. Basically, when it comes down to cost-per-wear, these pieces will end up being cheaper than anything fast fashion can offer. Plus, buying an investment piece or two means that you'll always have a little swank in your closet.

Coat

Idris Elba

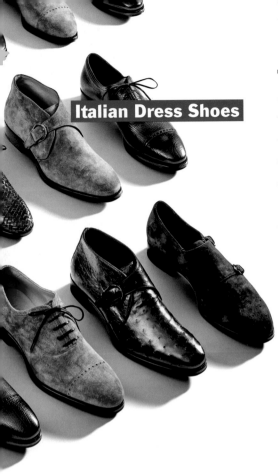

Italian Dress Shoes

Italian Dress Shoes

Whether you work in an office where you have to wear dress shoes every day or you just need them for special occasions, a high-end pair of Italian leather Oxfords is always a great investment. Not only will they look better than lower-priced dress shoes, they'll also be a whole lot more comfortable. This is because the premium leather and quality construction used will help them conform to your foot—almost like a second skin. And, as long as you take care of them—clean, polish, and occasionally resole them—they'll last pretty much forever. Think about it this way: no matter what stage of life you're in, you're always going to need a good pair of dress shoes.

A Coat

Of all the investment pieces you can buy, this one is undoubtedly the best in terms of cost-per-wear—assuming you live in a place that gets cold. A well-cut and *stylish* winter coat made from premium fabric will not only last you decades, but will also keep you warm and looking good every time the temperature dips. From December to March, this will be the investment that you'll value most because you'll literally be wearing it every day. Needless to say, it's well worth it.

Leather Jacket

A Leather Jacket

Bombers and windbreakers are certainly a great choice when the weather gets a little crisp. But if you want to add a sophisticated edge to your stylish and durable look, you have to go with a leather jacket. Whether you go full-on Marlon Brando with a black motorcycle jacket or stick with something a little more staid, it's hard to beat a well-cut leather jacket in terms of style and durability. And the best part is, it only gets better with age. After all, who doesn't love a leather jacket with a nice, well-worn patina? Sure, you might have to spend a lot of money up front, but in ten years' time, maybe even twenty, you'll be more than happy you made the investment.

A Tuxedo

In terms of investment purchases, a tuxedo definitely ranks below shoes and a winter coat, but it's still not a bad idea to take the plunge. Certainly as you get older, you'll likely find more occasions to wear it. And, given the price of a good rental, it'll have paid for itself after about four wears. Plus, when you buy your own tuxedo, you can get it tailored to your individual body shape, so it will fit like a glove. As long as you stick with black and a middle-of-the road cut, it will never go out of style.

A Watch

As guys, we don't get a lot of opportunity for bling. Well, we could go in for the whole man jewelry thing, but that's not exactly easy to pull off. A great watch, on the other hand, gives us the opportunity to put something elegant and beautiful on our wrists without coming off like Mr. T. It'll get people to take notice, but for all the right reasons. Plus, it's a great way to show you're a man of refinement and taste without resorting to overt displays of status. And, best of all, you'll always know what time it is.

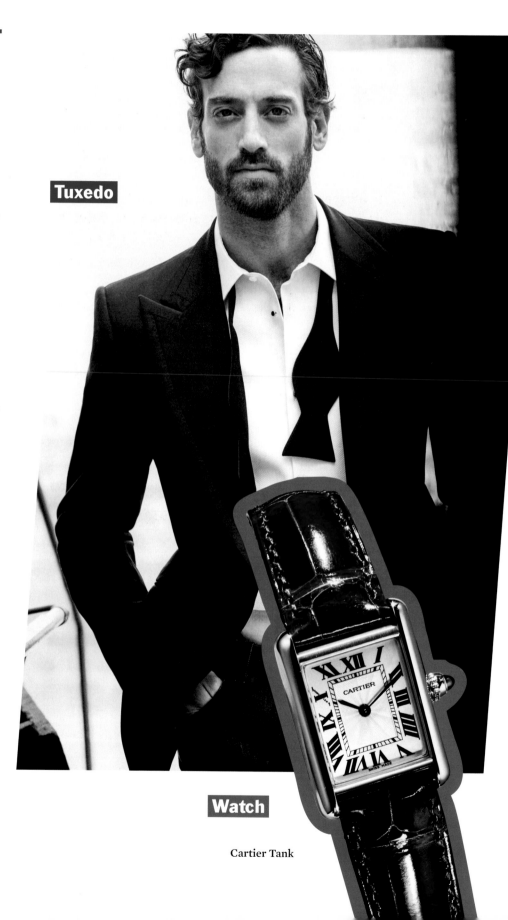

Tuxedo

Watch

Cartier Tank

Keep Your Leather Jacket Clean

The great thing about leather jackets is that they're fairly indestructible. But while they do stand up well to abuse, it's still important to keep them clean. Doing so will keep them looking great, plus it will increase the life span of the jacket. Luckily, cleaning a leather jacket is a fairly easy process.

Step One

Use warm water and a couple drops of dishwashing soap, or better yet a specialty leather cleaner, and apply it to a soft sponge. Rub down the outside of the jacket with soft, smooth motions. Avoid any forceful scrubbing.

Step Two

Clean away any residual soap with a damp towel. Then, with a dry towel, pat the surface of the jacket until it is dry. Hang the jacket up somewhere cool so that it can finish drying. Avoid any direct heat, like a clothes dryer or the sun, as this can be bad for the freshly washed leather.

Step Three

About once a year, apply a leather-conditioning cream to your jacket to keep the leather moisturized. This will leave it soft and flexible and will keep it from cracking. A leather conditioner is an especially good idea if you got caught in a rainstorm and the jacket got extremely wet.

Bonus!

Regardless of whether you have suede, lambskin, calfskin, or any other type of leather, you should always take the time to waterproof your jacket before you first wear it. A leather waterproofing spray seals the pores in the leather so that water will bead off the jacket rather than soak in. Ultimately, this will increase the life span of your jacket by a considerable degree.

Alden Ehrenreich

PERSONAL STYLE

TELLING YOUR STORY THROUGH CLOTHES

"Style is **KNOWING WHO YOU ARE**, what you want to say, and **NOT GIVING A DAMN.**"

—ORSON WELLES

For some, dressing is an art, a form of self-expression. For others, it's a daily hassle, best given as little thought to as possible. Regardless of where you fall on this spectrum, there is one unassailable truth about clothing—it tells a story about you. This is a strong argument for putting at least some effort into it. So why not control the narrative? The key, then, is simply to make dressing well an effortless exercise, almost like a reflex. And the best way to do that is by finding your own personal style.

KNOW THYSELF

LEARN TO MATCH HOW YOU FEEL ON THE INSIDE WITH WHAT YOU LOOK LIKE ON THE OUTSIDE

Great style requires a lot more than buying fashionable clothes. In fact, relying too heavily on what is fashionable can often lead you down bad sartorial alleys. Look no further than most '80s music videos for proof of that. Instead, think about how clothes can reflect your personality. This, really, is the crux of personal style—knowing not only what colors and fits work for you, but also what sort of aesthetic brings out your true personality. Are you a bit punk rock or more hip-hop? Are you the suave, suited type or something more blue-collar? To help you sort this all out, take a look at our breakdown of seven common men's style types and see what speaks to you. And don't worry: it's okay to embrace multiple types. In fact, that's half the fun.

The Tailored Traditionalist

It's basically impossible for a man not to look good in a well-tailored suit, so if this is your preferred aesthetic, prepare to receive many compliments. That being said, there are a few important tailoring elements to keep in mind if you really want a sartorial slam dunk. Whether you prefer Savile Row classicism or Continental *sprezzatura* (that is, artful insouciance), here are some suiting basics to put you on the right path.

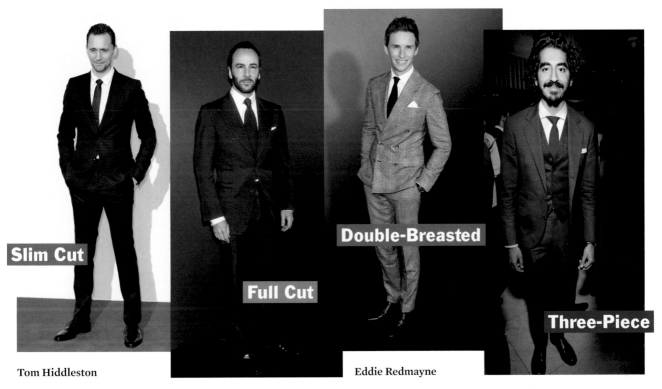

Slim Cut

Full Cut

Double-Breasted

Three-Piece

Tom Hiddleston

Tom Ford

Eddie Redmayne

Dev Patel

THE SUIT

Slim Cut. The key is to understand that slim doesn't mean too small. If you can see the outline of any part of your body (arms, shoulders, legs), you need a larger size.

Full Cut. This is the traditional Savile Row shape, with structured shoulders and a wider lapel and leg. In terms of longevity, this is the versatile suit that will never go out of style.

Double-breasted. The current DB is a crisper, more structured version than what we saw during the soft-shouldered Armani '80s. It's a great look for an adventurous personality.

Three-piece. Trickier to pull off if you don't want to look like a 1920s banker, but this upscale look is worth the effort. Just steer clear of wide pinstripes, and feel free to get a little adventurous with pattern or color.

The Suit

1800s: O.G. fashion peacock Beau Brummell takes elements of his cavalry officer's uniform—higher jacket armholes, shorter-cut jacket, trousers—and adapts them to his everyday dress.

1840s: The Victorian Era ushers in the age of trousers, waistcoat (aka vest), frock coat, shirt, collar, and cravat as the everyday male uniform.

1880s: To accommodate the sporting life of country gentlemen, frock coats were shortened and simplified, and trousers were widened. Not only does this make it more comfortable to hunt pheasant, but it also foresaw the modern suit silhouette.

1900s: The next step in country day wear is the invention of the sack suit—basically the precursor to the modern suit—which offers soft-front construction, a natural shoulder, and straight-leg trousers.

1920s: Once considered unrefined, the sack suit gets a makeover by Brooks Brothers to add respectability, and this gives birth to the modern suit. By the late 1920s, practically every man is wearing one.

1930s–2000s: With the template of the modern suit established, changes become more subtle. Lapels, jacket waists, and trouser hems grow wide, then narrow, then wide again. Through it all, though, the well-tailored suit remains a timeless staple.

Today: A decade ago the suit saw a major resurgence, then faded with the rise of athleisure. Now it's back again, only with more flexibility. Worn with ties or tees, in an array of colors, patterns, fits, and fabrications, it's tailoring for the social media age.

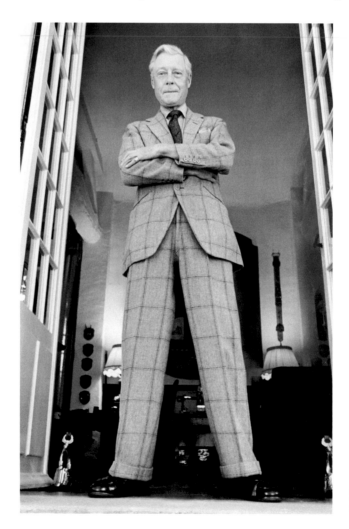

Edward VIII,
Duke of Windsor

THE STYLE

Savile Row. Structured, with more of an hourglass jacket shape and a sharp shoulder. This is classic British tailoring, best suited for traditional fabrics (worsted wool, flannel, tweed) and colors (grays, navys, browns).

Continental. Unstructured, with a straighter body shape and a soft shoulder. This is tailoring that's perfectly suited to warmer climates. While it works well with wools and flannels, it's especially stylish with summer-weight fabrics like cotton and linen. Bolder colors are ideal.

Go Casual. Switch your dress shirt for a plain T-shirt to take your suit from the office to a night on the town. And if you want to go even more casual, switch those dress shoes for a pair of classic or minimalist sneakers.

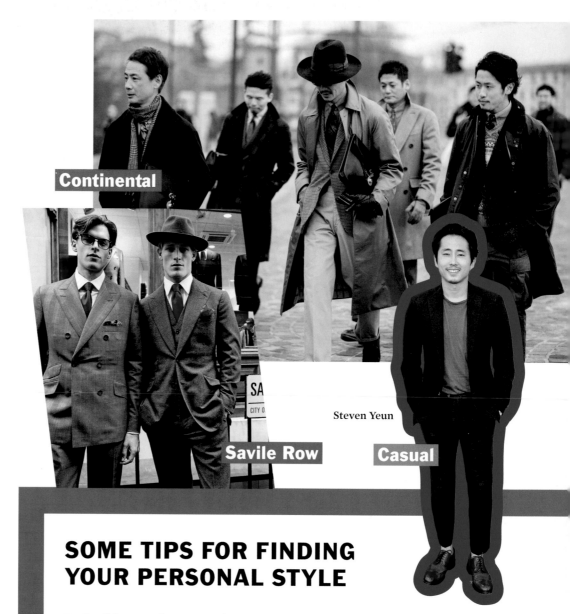

Continental

Savile Row

Casual

Steven Yeun

SOME TIPS FOR FINDING YOUR PERSONAL STYLE

Be flexible. Trends come and go, and you can easily become a slave to them. Just remember that people once thought flared crushed-velvet trousers were a good idea.

Play with different styles. Why dress preppy when you're in a rocker mood?

When in doubt, go for simplicity. A less-is-more approach is always better than wild extravagance.

Mix up your brands. Dressing in a head-to-toe look off the runway is the style equivalent of being in a cover band. It may look okay, but there's no originality.

Add a personal touch. A scarf, colored socks, a pocket square— it'll make people remember you.

Wear it with confidence. That's 90 percent of what makes for great style.

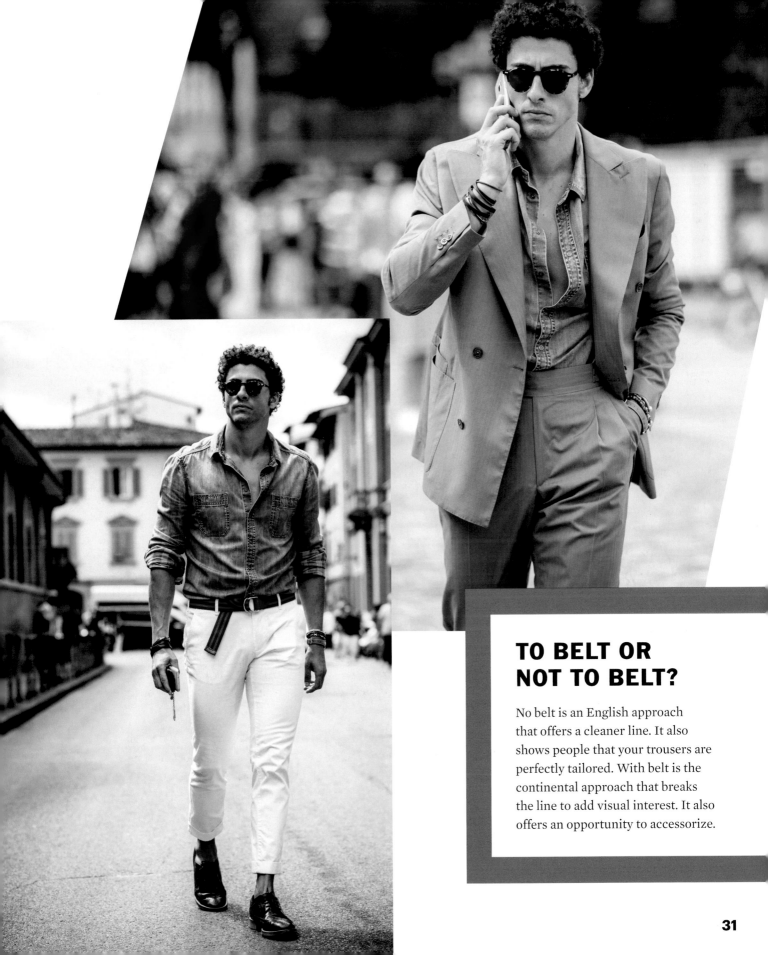

TO BELT OR NOT TO BELT?

No belt is an English approach that offers a cleaner line. It also shows people that your trousers are perfectly tailored. With belt is the continental approach that breaks the line to add visual interest. It also offers an opportunity to accessorize.

Fit Essentials

Slim, full, or something in between—it doesn't really matter what cut you choose as long as you nail the tailoring. After all, Cary Grant looked just as sharp in his fuller Savile Row suits as Frank Sinatra did in his '60s slim fit. Here are seven tips for getting it right.

1. The shoulder pads should end at your shoulders.

2. Your flat hand should slide easily under your lapel when your top or middle button is buttoned.

3. Your top button on a two-button suit—or middle button on a three-button suit—shouldn't fall below your navel.

4. With your arms at your sides, your knuckles should be even with the bottom of your jacket.

5. With your arms relaxed by your sides, the sleeves should just reach the point where your wrist touches the outside curve of your thumb.

6. Only a quarter- to a half-inch of your shirt cuff should be visible.

7. At the hem of your trousers, there should be either no break (your hem grazes your shoes) or a one-inch break (the back hem falls one inch below the top of your shoes).

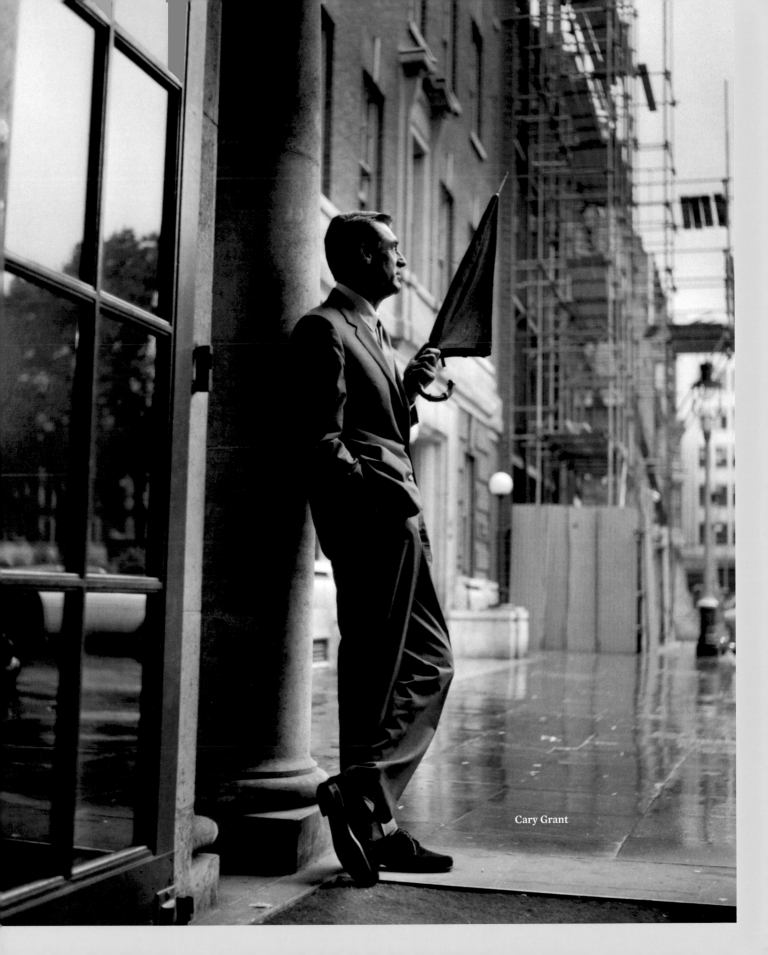

Cary Grant

The Street Style Star

Though it's not for the faint of heart, street style has certainly exploded in the age of Instagram. Wild colors, wild cuts, wild outfit combinations. If it has a chance of drawing attention, someone has probably tried it. While going all-in might be a bit risky for the average guy, it's certainly worth exploring the various lanes to find occasional dashes of creativity and inspiration to add a touch of panache.

Rick Owens

Health Goth

Hip-Hop

Skater

Sprezzatura

Maximalist

THE LOOKS

Skater. A simple, casual look made up of tees, classic skate shoes (Vans are among the favorites), hoodies, and jeans or work pants.

Sprezzatura. A well-tailored, continental style best described as elegant nonchalance.

Hip-Hop. A look that goes heavy on the casual athletic gear—sneakers, hoodies, track pants—and isn't afraid to accessorize.

Maximalist. Logos, accessories, chunky sneakers, bold graphics and prints—this is a look that goes big on everything.

Health Goth. A mix of athletic wear and fashion-forward silhouettes—overly drapey, loose straps, exaggerated proportions—predominantly in the color black.

THE STYLE

For the man who wants his wardrobe to really stand out, street style is the way to go. It's definitely for anyone who loves to experiment. Just keep in mind that it's a personal style that will require maximum effort to maintain. Here's how:

Stay on top of the latest trends. Whether it's the latest sneakers or the designer everyone is buzzing about, when it comes to street style, latest is definitely greatest.

Mix up your silhouette. Aside from the suit-clad sprezzatura look, this style is all about playing with proportion. Big on top, skinny on bottom or vice versa. Sleek, super low-profile shoes or chunky sneakers—exaggerated shapes are important.

Play with colors and patterns. While health goth is relatively easy— all black—most street style involves a heavy dose of mixing color and pattern. Again, it's all about trying to stand out.

Graphics and logos. At the moment, logos are in. Big brash ones. But even when they're not, bold graphics are still an important part of many avenues of street style.

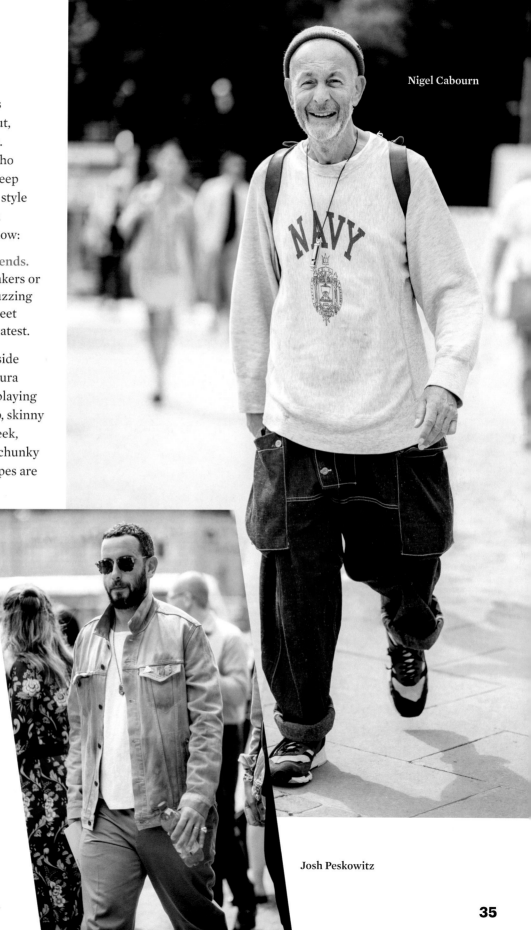

Nigel Cabourn

Josh Peskowitz

Sneaker Lesson

Sneakers are everywhere these days. They're not going away, so it pays to find your place in the sneaker spectrum. You can go anywhere from down-home canvas to sneakers so posh they work (just about) with a suit. Or you can go all out and embrace the high fashion multicolor dad sneaker. Ultimately only you can decide what you want your sneakers to say about you. They can either whisper or shout.

Running sneaker

From retro favorites like Nike Air Max to contemporary styles like Adidas NMD, running sneakers are a great middle ground between chunky basketball sneakers and low-profile classic or court shoes. The easiest way to wear them is with cropped jeans, chinos, or trousers.

Basketball sneaker

The style that kicked off our modern sneaker phenomenon—you can thank the Air Jordan for that—these are the chunkiest, highest-profile sneakers in the sneaker-verse. Try them with wider-leg cuffed or cropped jeans, or, if you prefer a skinnier fit, go with slimmer, longer jeans that you can stack (that is, scrunch the hems up at the bottom).

Classic sneaker

From Adidas Stan Smiths to Vans Authentics to the ultimate retro sneaker, Converse Chuck Taylor All-Stars, classics are by far the most versatile. This is all thanks to their low profile and low-key styling. Wear them with just about anything— jeans, shorts, chinos, or a suit. The sky really is the limit.

Minimalist sneaker

If you want something with a high degree of versatility but that's a little more modern, a good minimalist sneaker is the way to go. Although there are many to choose from, the Common Projects Achilles Low is still the standard bearer. Sleek, clean, and simple, this is a sneaker that will work with just about anything.

The Bohemian

Whether it's a scarf thrown casually around your neck, a bit of artful layering, or a heavy reliance on wide-brimmed hats and faded jeans, bohemian style is a look built around insouciance. The key is never to let anything look too sharp or overly thought out. It should look like you just threw it on, and, when you threw it on, it also just so happened to be super-stylish. From the college professor look to the '60s rocker look, it's all about confidence.

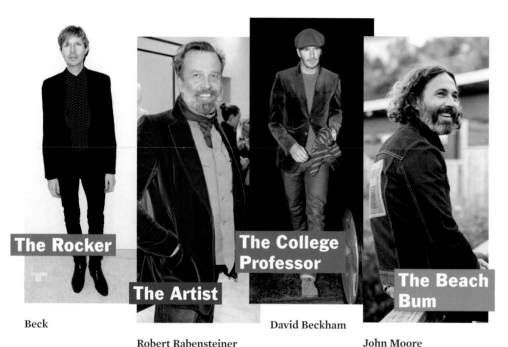

The Rocker

The Artist

The College Professor

The Beach Bum

Beck

Robert Rabensteiner

David Beckham

John Moore

THE STYLE

Don't overdo it. The point is to look put together without looking like you thought about it too much. Bohemian style should come across as your natural state of being. A casual scarf here, a hat or beaded bracelet there; not fifteen different accessories all at once.

Master layering. Pairing new with vintage, combining multiple textures, or even mixing high and low. No matter the contrast, it's all about maintaining a degree of variety in your look.

Faded is your friend. Crisp and polished is definitely not bohemian style. You don't want your clothes to look beat-up, but they should look like you've worn them a few times before.

No matter what, though, make sure to steer clear of sloppy. Everything should still fit properly. Looking like a kid in his brother's hand-me-downs or, worse, like a thrift store exploded all over you, is not style. It's a cry for help.

THE LOOKS

The Rocker. This is all about the skinny silhouette—skinny jeans, skinny boots, skinny tie. And, of course, the black leather motorcycle jacket.

The Artist. Lived in and layered is the focus of this look. A little beat-up, a little loose, plus plenty of creativity.

The College Professor. Also known as "tweedy," this is a more tailored style that puts an emphasis on texture— both tactile and visual.

The Beach Bum. Loose fits, light shades, and a lot of cotton and linen are the cornerstones of this laid-back look.

The Old-Timer

For the first half of the twentieth century, workwear was nothing more than durable clothing made to withstand the abuse inflicted by a blue collar job. But as style grew more casual during the second half of the century, that old workwear—especially in its most well-worn, beat-up form—took on a second life as nostalgia-soaked vintage fashion. It's a style that, starting in the early aughts, also came to include British heritage wear—a lineup of durable country styles made up primarily of tweeds, knits, and waxed cottons. Today, thanks to that heritage movement, you can now dress the way your great-grandfather did, assuming your great-grandfather was an American factory worker or an English country gentleman.

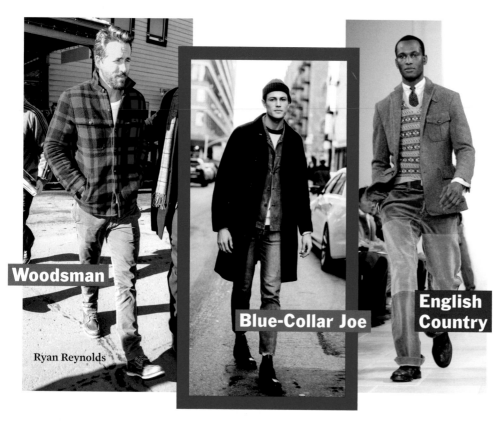

Woodsman

Ryan Reynolds

Blue-Collar Joe

English Country

THE LOOKS

Woodsman.
An outdoors-y look that involves plenty of flannel, layers, and chunky-soled boots.

Blue-Collar Joe.
This style is a throwback to the lunch-pail workers of the early twentieth century. Plenty of denim and thick, durable fabrics.

English Country.
Nothing is better for a damp day in the English countryside than a gentlemanly mix of knitwear, tweeds, and waxed cotton jackets.

THE STYLE

Denim is your workhorse.
Though there are many elements to heritage Americana, the foundation of it is denim. More specifically, the denim should be heavyweight, raw, selvedge denim that's meant to be broken in by its wearer (rather than at the factory).

It's all about the patina.
In the world of heritage wear, new is never better. The point of all this durable clothing is that it gets better with age. That said, it's better to earn that patina on your own for style that's truly personal.

Dial it down a notch.
The great thing about heritage wear is that it can mix and match with a lot of different styles. As a foundation of your overall wardrobe, it's a solid idea. Just avoid looking like you should come with a hard hat and lunch pail.

Know your history.
Authenticity is important in this sartorial realm. A pair of 1954 Levi's 501xx Cone Mills denim jeans will not only look better and last way longer than some off-the-rack knock-off, they'll also show that you really care about your clothes.

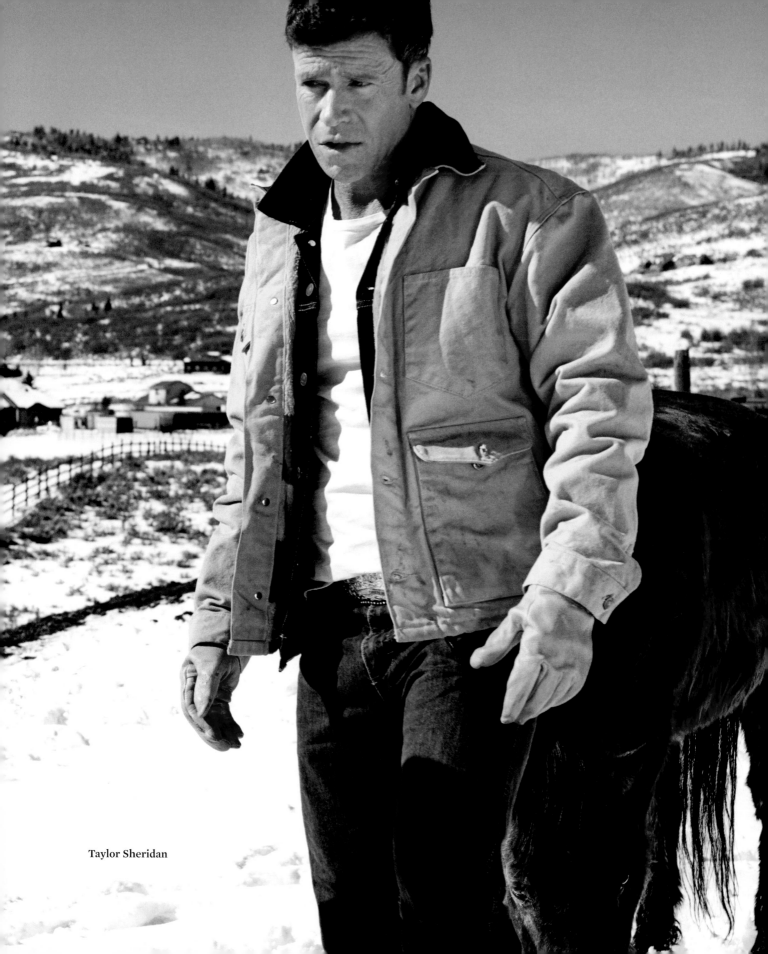

Taylor Sheridan

Denim 101

Whether you're looking for Japanese or American, raw or washed, selvedge or non-selvedge, here are a few key tips to understanding the universe of denim.

Selvedge

Something of a buzzword in denim these days, selvedge is actually just a fabric that's been woven with a finished edge to keep it from unraveling (the name comes from the technical term for this process, "self-edge"). Before the 1950s, all jeans were made from selvedge denim, woven on shuttle looms. After the 1950s, most denim manufacturers switched to jet looms, which can weave at a faster pace and in larger quantities, but they leave the edge unfinished. While selvedge denim has come to be viewed as a mark of quality, the fact is, it isn't inherently better. A well-made pair of non-selvedge jeans will be superior to poorly made selvedge jeans.

Japanese Versus American Denim

The Japanese obsession with denim began shortly after World War II, when American GIs unloaded their old pairs of Levi's on the Japanese black market. Especially among Japanese youth, the fervor for vintage Levi's—specifically World War II-era selvedge jeans—only escalated during the decades after the war. But, as the supply of vintage denim was limited, especially after American brands switched to jet looms, the Japanese had to start producing their own denim to meet demand. Preferring the tighter weave of selvedge denim, Japanese mills stuck with shuttle looms for their fabric production, eventually becoming the primary producers of high-end selvedge denim.

Sanforized Versus Unsanforized Denim

Essentially this is just a fancy way of saying pre-shrunk versus shrink-to-fit jeans. With sanforized denim, aka pre-shrunk denim, the fabric is stretched, fixed, and shrunk at the mill to prevent the jeans from shrinking when they are washed, Usually, this limits shrinkage to around 5 percent or less. Basically, it's a way to produce raw jeans that won't shrink much when you get them wet. With unsanforized denim, aka shrink-to-fit, the sanforization process is bypassed, which means that your jeans can shrink up to 10 percent after their first soak or wash.

For denim purists, unsanforized is preferable, mainly due to texture. With sanforized denim, the fabric is flattened, which eliminates the rougher, slightly fuzzier feel—especially post-wash—of classic, unsanforized denim. There is also the matter of that first soak to shrink your unsanforized jeans. It's a ritual that, for many denim heads, is akin to a religious ceremony.

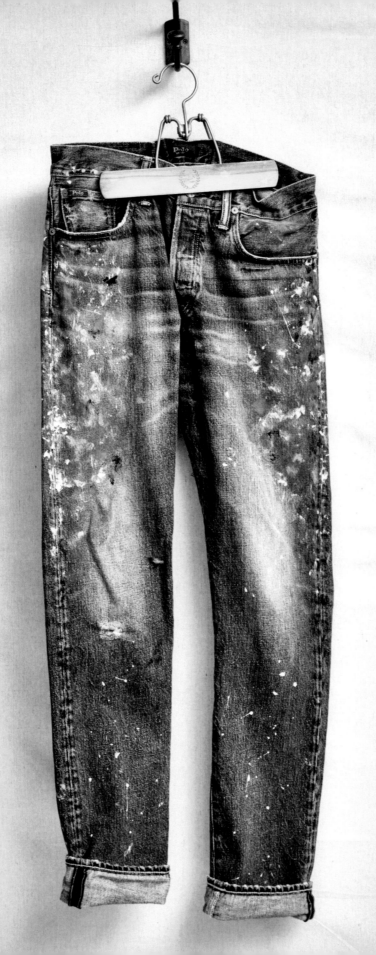

The Prepster

A direct descendant of the East Coast preparatory school uniform, preppy style is a look that skews crisp, buttoned-down, and conservative, but not *too* crisp, buttoned-down, and conservative. A bit of rumpled nonchalance—i.e. how an actual prep school student would wear it—is definitely the ticket. Think JFK sailing around Hyannis Port, or Andrew McCarthy's rich kid romancing of Molly Ringwald in the '80s classic *Pretty in Pink*.

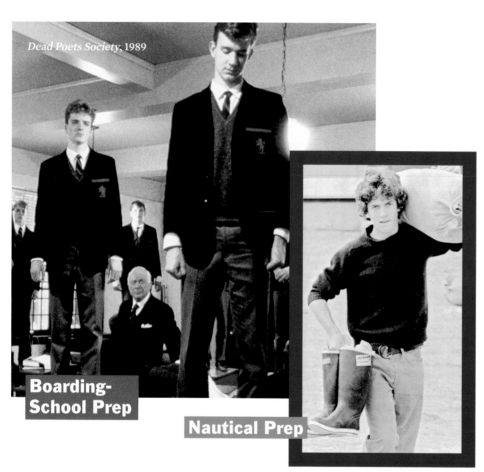

Dead Poets Society, 1989

Boarding-School Prep

Nautical Prep

John F. Kennedy, Jr.

THE LOOKS

Boarding-School Prep. A look derived from the archetypal prep school uniform of navy blazer, khakis, Oxford shirts, and classic knitwear.

Nautical Prep. This is an East Coast maritime style made up of crisp shirts, shorts, windbreakers, and chinos in a mix of white, khaki, red, and navy blue.

Southern Prep. The key to this style is in its light fabrics, check patterns, and, most importantly, its wide range of soft pastels.

THE STYLE

Keep it traditional. Prep style really hasn't changed much in the last seventy-five years, so the key to maintaining this look is to stick with the tried-and-true classics. Chinos, Oxford shirts, navy blazers, polos, and boat shoes will be doing your sartorial heavy lifting.

A lived-in look. Whether it's a navy blazer and tie or a polo shirt and shorts, the main thing to remember is that preppy style is largely derived from student uniforms and sportswear. This means it should never look too pressed or stuffy.

The proper color palette. For East Coast prep, the colors tend to be a little more conservative. Your navy blue, light blue, or khaki, maybe with a splash of red and white for that nautical touch. Southern prep, however, adds pastels to keep things light and summery.

The proper footwear. With prep style, it basically comes down to three tried-and-true stalwarts: black Oxfords for dressier occasions, boat shoes (Sperry's classic Top-sider is a popular choice) for any middle-of-the road events, and white canvas sneakers for anything active.

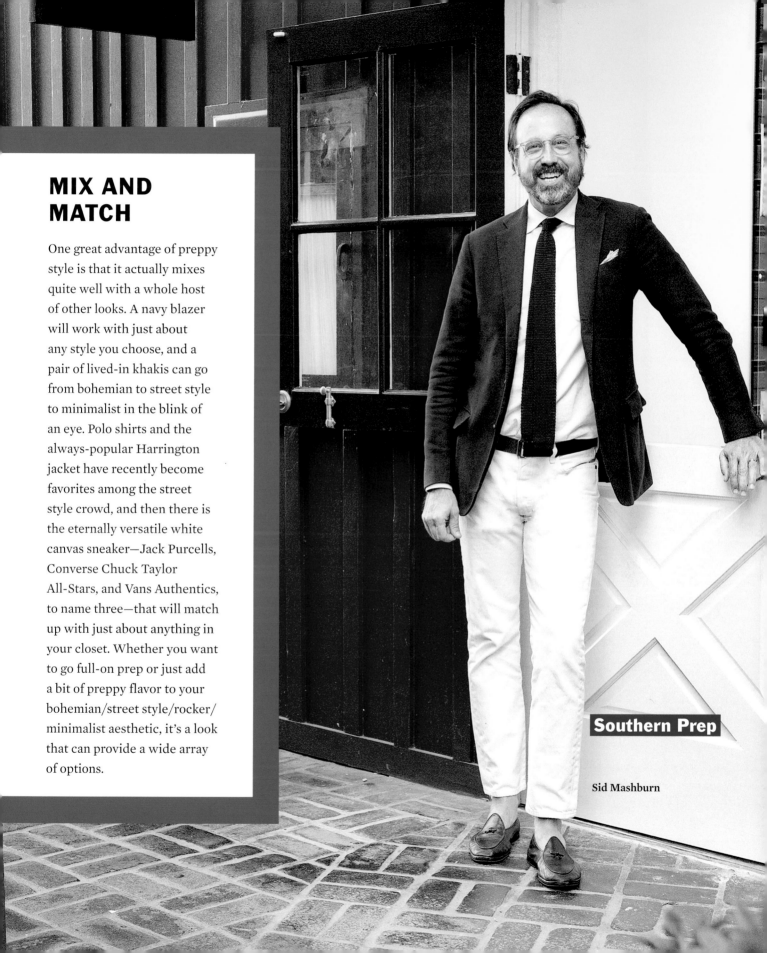

MIX AND MATCH

One great advantage of preppy style is that it actually mixes quite well with a whole host of other looks. A navy blazer will work with just about any style you choose, and a pair of lived-in khakis can go from bohemian to street style to minimalist in the blink of an eye. Polo shirts and the always-popular Harrington jacket have recently become favorites among the street style crowd, and then there is the eternally versatile white canvas sneaker—Jack Purcells, Converse Chuck Taylor All-Stars, and Vans Authentics, to name three—that will match up with just about anything in your closet. Whether you want to go full-on prep or just add a bit of preppy flavor to your bohemian/street style/rocker/minimalist aesthetic, it's a look that can provide a wide array of options.

Southern Prep

Sid Mashburn

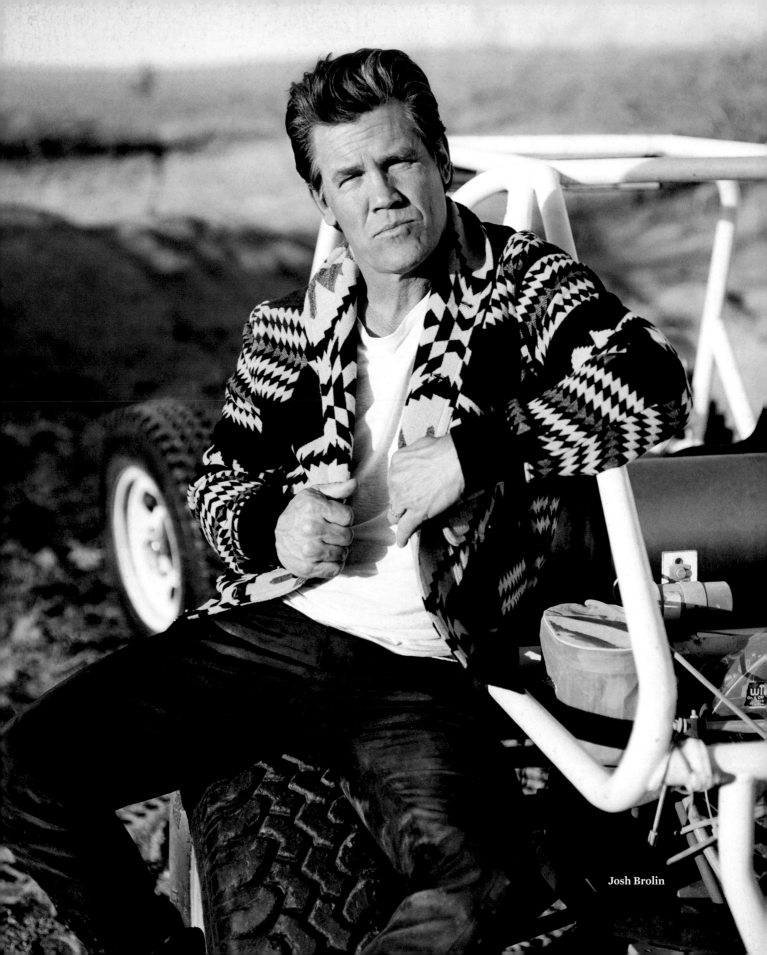

Josh Brolin

HOW TO DRESS FOR EVERY STAGE OF LIFE

LOOKING GREAT THROUGH EVERY DECADE

"Know first **WHO YOU ARE**, and then **ADORN YOURSELF** accordingly."
—EPICTETUS

While there are plenty of items in a man's closet that can be worn regardless of age, there are a few styles that should definitely come with an expiration date. Backwards baseball hats and comic book T-shirts, for instance, should probably fall by the wayside after college. Ditto anything that's excessively distressed, anything with "clever" graphic slogans, or anything acquired for free at a sporting event. After all, aging isn't just about getting older; it's also about maturity and respect. And no one is going to respect a middle-aged man wearing an oversized Boba Fett T-shirt.

continues »

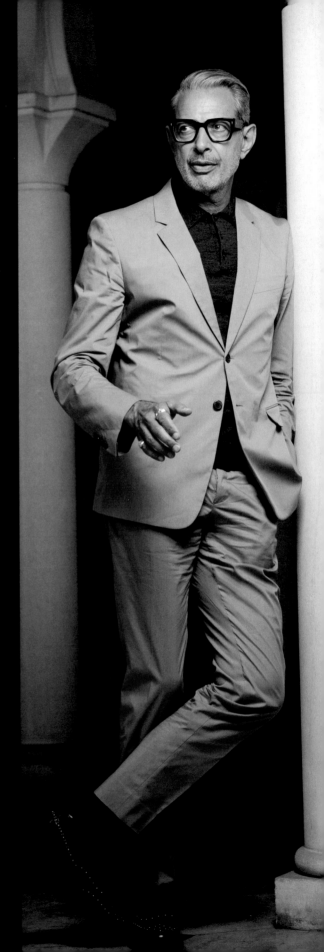

3 ▸ HOW TO DRESS FOR EVERY STAGE OF LIFE

« *continued from previous page*

Evolving your style over time doesn't mean you can't have fun with it. It just means that you should change your perspective on what qualifies as fun. Like favoring a new watch over a hype-worthy pair of sneakers. Or a stylish blue velvet dinner jacket for that black-tie New Year's Eve party instead of a regular black tux. And, most importantly, staying stylish as you age is about more than just knowing what to get rid of; it's also about knowing how to replace it. And *when* to replace it. Like when to make the transition from wild retro Jordans to a pair of sleek minimalist low-top sneakers. And when to replace those minimalist sneakers with suede desert boots. It's all about working with your age rather than against it. It's also about knowing how to have fun without looking like the guy who can't shake the Peter Pan complex.

Jeff Goldblum

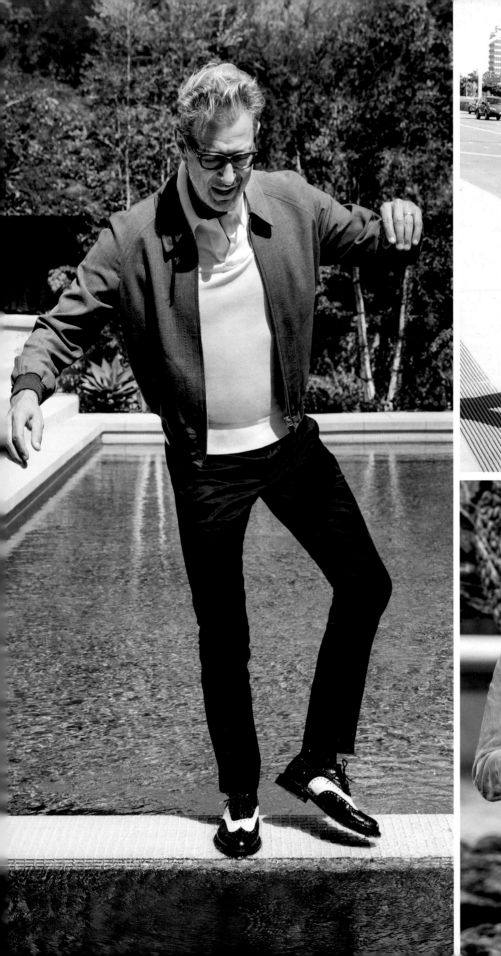
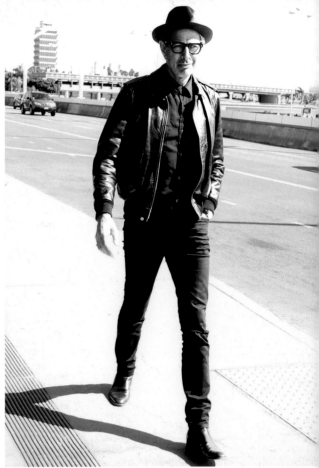
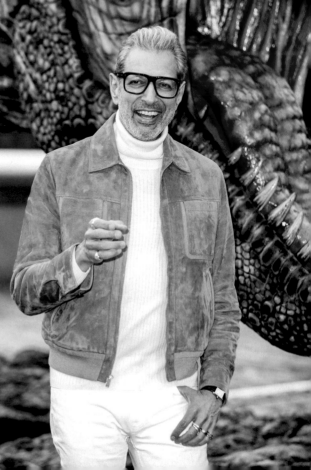

YOUR TWENTIES

In navigating your twenties, you're seeking the right path toward adulthood, at least sartorially speaking. And while it's hardly time to settle in for bland colors and sensible shoes, it is time to start thinking about how to dress like an actual grown-up. The good news is, hopefully you're still pretty fit and trim. And you're also still young enough to get away with a little bit of experimentation, which means you have a pretty wide scope in terms of deciding what to wear. The downside is that this extremely transitional decade can be tricky to navigate. The best way to approach it is just to understand that it's all about learning how to be an adult. Here are a few tips for making that transition.

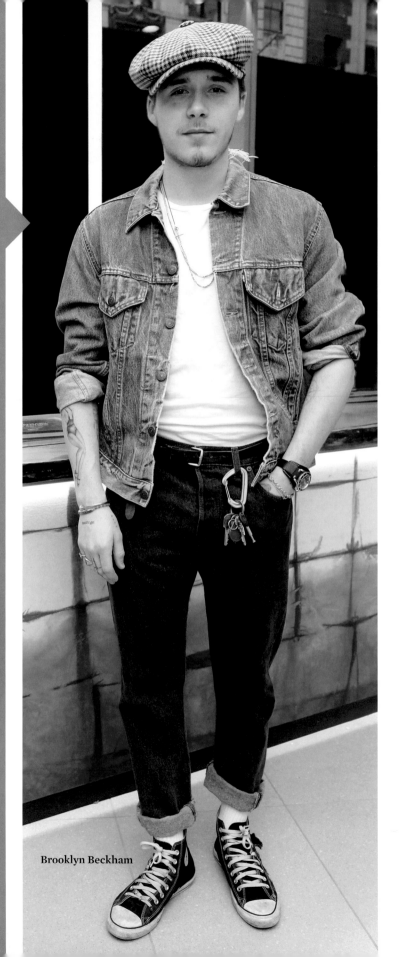

Brooklyn Beckham

Move toward a Slimmer Cut

Baggy is an adjective that should exit your sartorial vocabulary once you hit the legal drinking age. Not that you should overcompensate and go super-skinny, unless you plan on starting a Strokes-style rock band. It's just that you should find clothes to flatter your hopefully still-slender frame.

Jayson Tatum

Time to Buy a Suit

Your twenties tend to be the age of job interviews and weddings, so you're going to need a good suit to get through them. This isn't the age to worry about going full-on Savile Row, but you should still buy the best suit you can afford. One option is to get an affordable custom-made suit from an online company like Indochino, J. Hilburn, or Astor & Black. By eliminating the middleman (that is, physical stores), they're able to take your measurements and deliver you a suit made to your specifications. It's not quite Savile Row, but for a young man on a budget, it's a good way to get a suit that fits. And, most importantly, get it tailored by a good tailor. This leads us to our next tip.

Timothée Chalamet

RIP: WHAT TO GET RID OF NOW THAT YOU'RE IN YOUR TWENTIES

Athletic team jerseys. You don't have to get rid of them, but you shouldn't be wearing them outside of a sporting event.

Novelty T-shirts. No one cares that you're "with stupid."

The free tote bag that you received when you opened your bank account. It's time to invest in a proper messenger bag or backpack.

Wraparound sunglasses. Unless you're riding in the Tour de France.

Flip-flops. Except when you're on the beach.

Deep V-neck T-shirts. Man cleavage should never be part of your sartorial vocabulary.

Find a Good Tailor

One major key to looking stylish once you've hit adulthood is to look put together rather than thrown together. And the best way to do this is to find a tailor who can make your wardrobe—not just your suits, but your shirts, casual pants, and jackets, too—fit you like a glove. Don't rely on the Russian roulette of off-the-rack clothing. Get a good tailor and you won't have to worry about ill-fitting clothes again.

Experiment, but within Reason

The great thing about your twenties is that you're still young enough to get away with some pretty out-there styles. Want to go skinny rocker? Knock yourself out. Feeling a health goth–ninja vibe? By all means, drape yourself in dystopian black. Just make sure to keep it reasonable. You want to be known as a guy who likes his fashion, not as the guy who was victimized by it.

Invest in Some Proper Dress Shoes

Sneakers with a suit are great for a casual look, but for anything dressy, you need proper dress shoes. This isn't your junior high graduation, after all. Just like the suit, buy the best that you can afford—preferably in both black and brown. If you're on a budget, just black is fine. High-quality dress shoes will last a lot longer than inexpensive ones, so they'll save you money in the long run. Plus, they'll look better and wear better.

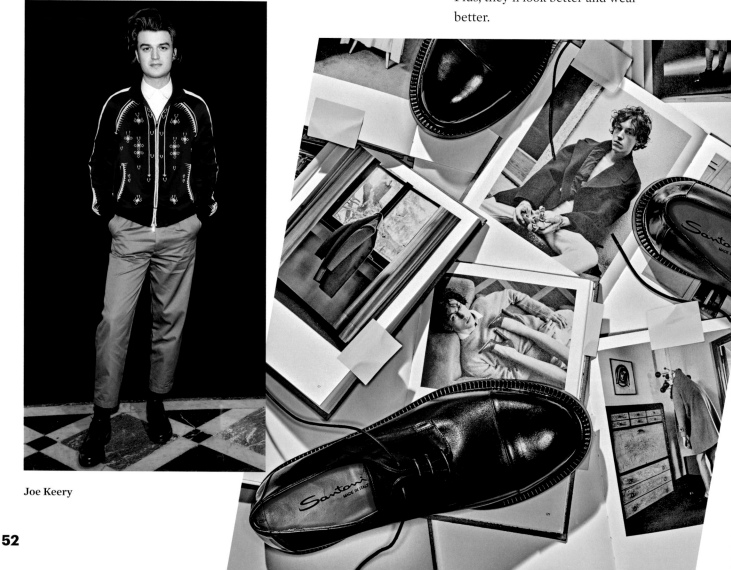

Joe Keery

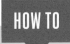

Find A Tailor

Ask around. Sure you could Google it, but you'll do better asking either a stylish friend or someone at your local menswear shop. Of course, if you don't have stylish friends and your best local menswear shop is Target, then check Yelp and Google.

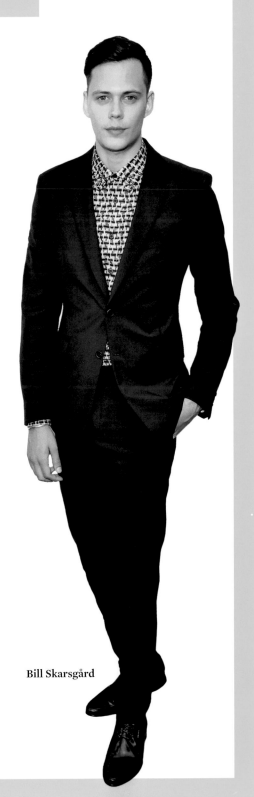

Bill Skarsgård

Give them the phone test.

Once you've found a tailor, call him up and ask if he can shorten a jacket sleeve from the shoulder. This is one of the more difficult alterations. If he says he can do it, it means he's a true tailor instead of a seamster (someone who can shorten a hem).

Check his work.

Once you've settled on a shop, go in and ask to look at a recent alteration. Most good tailors are proud to show off their work, so they shouldn't mind. Look for any loose threads or wonky stitching. If everything looks clean and sharp, you've found your match.

Test-run something small.

Don't go to a new tailor with your favorite $3,000 Italian suit. Give him something you don't care about first as a test run. Maybe you have a shirt that's a little big on you. Bring it in and see if he can turn it into the best-fitting shirt of your life. If he does, you know you can trust him with your big-ticket items.

Develop a relationship.

If he's good, you'll want him in your corner. Build a good rapport and compliment him on his work. Sure you're paying him, so a level of quality should be expected. But if you build more of a personal relationship, he's more likely to go the extra mile. At the very least, he'll remember you and know what you like without having to explain it each time you come in.

Sneaker Guide for Your Twenties

At this age, sneakers are still acceptable for a wide range of situations, which is especially convenient if you happen to be a sneaker fanatic. That said, you should think about upgrading and editing your sneaker lineup once you've hit your first decade of adulthood. That one ragged pair of Chuck Taylors you wore every day in college just isn't going to cut it anymore. These are the essentials you should have on your shoe rack.

White sneakers

Whether you go for something contemporary, like Common Projects Achilles, or something old school, like Jack Purcells, it's important to have one pair of all-white sneakers that you can wear with just about anything.

High-end running shoes

Welcome to the age when your metabolism starts to slow down. Get yourself a pair of quality running shoes and hit the pavement to stay in shape.

Classic canvas sneakers

It's always good to have a retro look or two in your closet, and classic canvas sneakers are the perfect solution. Whether it's a pair of Converse All-Stars or Vans Old Skools, these are sneakers that will never go out of style.

Basketball shoes

You can play basketball in them, work out at the gym in them, or just wear them on the weekends for a casual, street style look.

Something trendy

Your twenties are your last chance to wear a pair of trendy sneakers without fear of judgment. Go nuts with something that will stop people on the street.

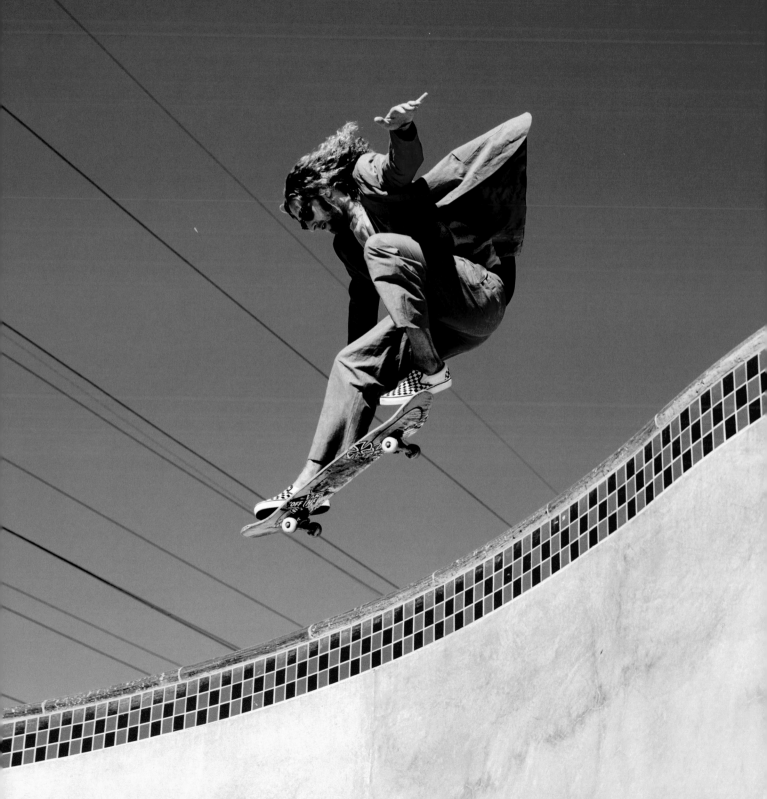

YOUR THIRTIES

By your thirties, you should have a good idea of what works for you and what doesn't. So this is the decade when you finally drill down on your own personal style. It's a good time to start curating your wardrobe to include only a few favorite brands. Introduce the word elegance to your sartorial vocabulary. Hopefully, your career is starting to take off, which means you'll likely need to fill out your suit selection. And you'll also have to start thinking about upgrading various accessories—like your watch, your dress shoes, and your workbag. Here are some tips to get you through this important decade.

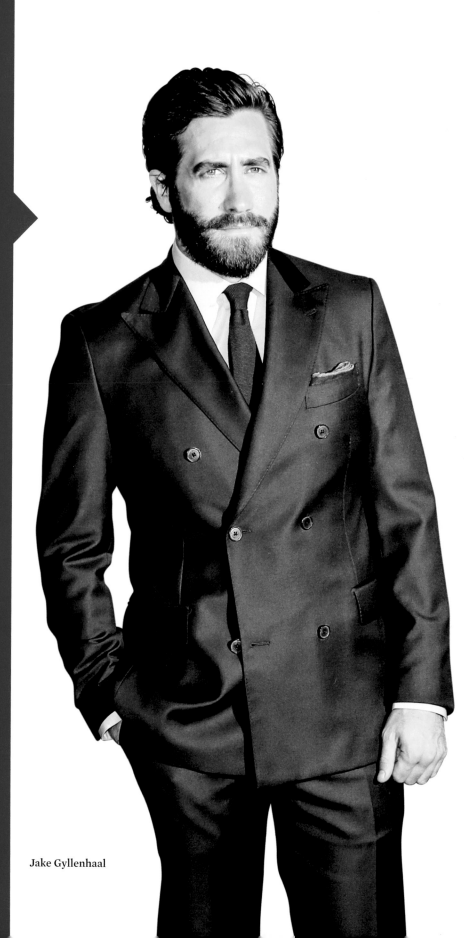

Jake Gyllenhaal

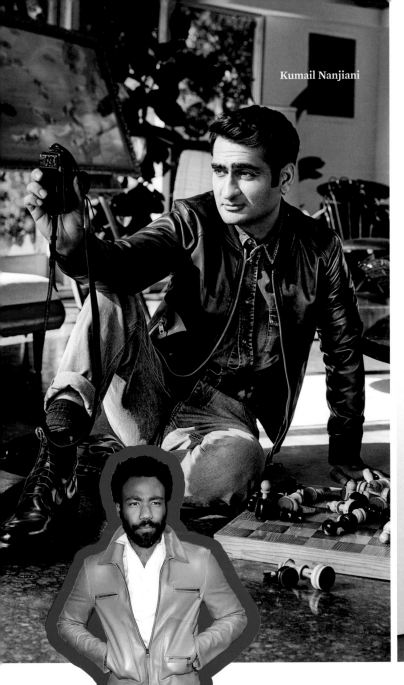

Kumail Nanjiani

Donald Glover

Eddie Redmayne

Thirties Casual Is Different from Twenties Casual

The trick to casual in your thirties is that it should be a more polished look. Think crisp crew-neck sweaters rather than hoodies, and chinos and dark indigo jeans rather than beat-up old denim. And, of course, by now you should have a good relationship with your tailor, so everything should fit perfectly. Also, your footwear lineup shouldn't be as sneaker-heavy. Desert boots, casual work boots, a pair of suede derbies—these should be added to the rotation alongside your classic canvas and minimalist white sneakers.

Sneaker Guide for Your Thirties

While we're certainly living in the age of the sneaker, by thirty there are a few extra guidelines that you should probably consider. For one thing, no one (in your age group, anyway) will likely be impressed when you wear a different pair of sneakers every day for six months. Unless you're a committed sneakerhead (aka sneaker fanatic), you should probably start editing your sneaker collection and getting rid of all but the most low-key of styles. Here's what you can keep.

Classic canvas sneakers

The older you get, the more Chuck Taylors, Jack Purcells, and Vans Authentics will become your off-duty stalwarts. These are shoes that have stuck around thanks to their timeless appeal.

Minimalist designer sneakers

The crisper and more polished your wardrobe gets, the more a pair of leather designer sneakers from high-end brands like Tom Ford, Lanvin, or Acne Studios will come in handy. They work with anything from suits to chinos to shorts, and they will keep you casual and comfortable without looking sloppy.

Retro sneakers

Whether it's something simple, like Stan Smiths or Adidas Gazelles, or something with a bit more color, like early Air Jordans or Air Max 1s, an old-school sneaker is still okay for casual occasions.

Running shoes

You're basically at the last stage of life when you can pull off running shoes for anything other than running. That being said, you should probably stick to retro models like the Nike Air Max 1 or the New Balance 990.

Expand Your Tailoring Selection

A tailored look should start to become the backbone of your wardrobe. Unless you work in an extremely casual environment, you should have, at the very least, a navy and a charcoal suit, and maybe even something in a bolder color—like a brighter blue or a burgundy. A black suit is never a bad idea, either. Although some might say they're only for funerals and clergy, as long as the occasion isn't too conservative, they're totally acceptable. Just look at Tom Ford. Also keep in mind that each suit can function as separates as well—think a blazer and trousers—so one suit can make up three totally different outfits. And, of course, as with everything in your closet, make sure they're all tailored to perfection.

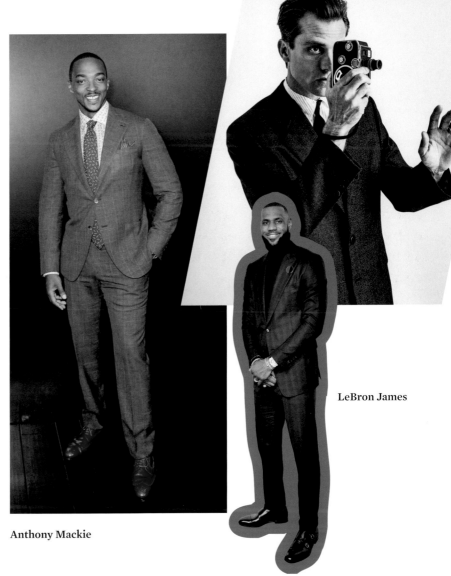

Anthony Mackie

LeBron James

Settle on a Few Favorite Higher-End Labels

Hopefully, the experimentation you did in your twenties led you to a few favorite brands and shops that you can lean on heavily in your thirties. By trimming your choices down to a few go-to labels, you'll not only make shopping easier, you'll also have an easier time creating a signature look. Plus, you can bulk up on the essentials, like T-shirts and button-downs. Knowing that every Oxford shirt or white tee in your closet is exactly the same makes getting dressed in the morning a breeze. And don't be afraid of trading up to a higher price point. You don't have to go full Gucci, but something in the upper midrange—brands like Todd Snyder, Billy Reid, or Acne Studios—will give you a wardrobe that not only impresses, but will last a long time as well.

Time for a Few More Investment Pieces

By now, you should hopefully be making enough to treat yourself to a few big-ticket items. In this regard, the most obvious choices are a watch, a leather workbag, and a nice leather jacket. A really high-end winter coat—something that's wool (or maybe even cashmere) and tailored—should also be considered. Basically, these are the few statement pieces that will not only last you the rest of the decade (or longer), they'll also show off your high level of taste. Some other upgrade possibilities are a nice set of cuff links, a proper umbrella, and an expanded shoe collection. And, in the knitwear department, you're going to definitely want some cashmere.

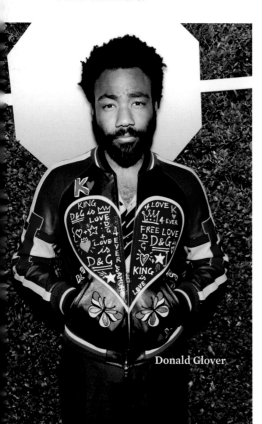

Donald Glover

Master Warm-Weather Style

Throughout your twenties, warm-weather "style" probably meant a T-shirt and shorts, or maybe a pair of jeans. But now is the time to think about actually looking good when the mercury rises. Light cotton or linen trousers are a far more stylish warm-weather option than shorts, and a light cotton suit will come in extremely handy for those midsummer weddings and dressier occasions. You should also definitely make espadrilles or loafers your summer footwear of choice. As for days at the beach, switch out those baggy board shorts for a stylish pair of swim shorts from brands like Orlebar Brown, Saturdays NYC, Vilebrequin, or Onia. And when the weather gets too hot for pants, a light pair of crisp linen shorts will keep you cool and looking sharp.

Finn Wittrock

Black Tie Is No Longer Optional

You should really invest in a tuxedo or a dinner jacket and dinner suit, especially if you find yourself at a lot of events that call for black tie. You'll find that it ends up being a more cost-effective strategy than renting, and, since you can get it tailored, you'll end up looking more like James Bond and less like a guy at his junior prom.

RIP: WHAT TO GET RID OF IN YOUR THIRTIES

Sweatpants. Barring sick days on the couch, sweatpants should no longer be part of your sartorial collection.

Cargo shorts, baggy shorts, athletic shorts (except for the gym). Some well-tailored cotton or linen shorts for those unbearably hot days are still acceptable.

Technical rain jacket. Unless you're trekking through the Andes, a solid mac or trench coat should be your rainy-day go-to.

Logo T-shirts. The odd graphic tee under a blazer is okay. But mostly you should be sticking to tees in solids or stripes.

Complicated sneakers. Those Air Jordan XIs were cool when you were 22. Now they're dragging you into frat-boy territory.

Bill Hader

YOUR FORTIES

Now that you've hit your forties, you're in that weird place where you're no longer young, but you're not exactly old, either. This is not necessarily a bad thing. It's the decade, after all, when you can finally command a bit of respect and begin affording the finer things in life. By now you should have a fairly solid handle on your sartorial identity, which means that it's time to focus on style and stop thinking about fashion. Basically it's the time when you combine everything you've learned over the past two decades with a healthy enough bank balance to fund the best version of your personal style. And, for some of us, anyway, it's a decade when we start thinking about clothes that will flatter our changing body types.

Justin Theroux

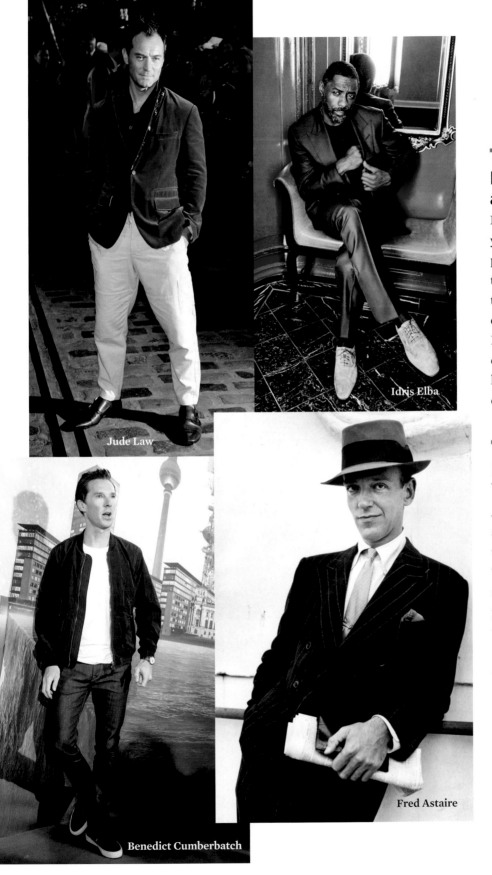

Jude Law

Idris Elba

Benedict Cumberbatch

Fred Astaire

Rethink What Qualifies as Casual

By your forties, most of what you now consider sportswear is probably out. Hoodies, track pants, track jackets, even most sneakers—these are things that you should only be wearing while working out. Instead, your casual style should consist primarily of high-quality knitwear, trousers, chinos, button-down shirts, and slim, dark jeans.

Further Upgrade Your Wardrobe

At this point, you can hopefully afford the transition from J. Crew to Tom Ford. Or, at the very least, Thom Browne. The words *off-the-rack* should no longer be part of your vocabulary. Stick to brands that will up your elegance factor and will outfit you in only the best cuts and materials.

RIP: WHAT TO GET RID OF IN YOUR FORTIES

Basically anything with graphics on it. If it's got a zig, a zag, or a Guns N' Roses logo, it's reached its expiration date.

Any and all athletic wear that's not specifically used for athletics. Hoodies, sweats, track pants, team apparel.

Backpacks. At this point, your workbag should be a briefcase or an attaché case, or maybe an upscale messenger bag.

Fashion-forward eyewear. No giant rhinestone frames, no Kurt Cobain sunglasses—just stick to something in the ballpark of classics, like aviators, Wayfarers, or Clubmasters.

Michael Shannon

Alasdhair Willis

David Beckham

Bespoke Is Your New Favorite Word

Suits, dress shirts, even shoes—this is the age when custom-made items should become part of your regular rotation. For one thing, it will mask any age-related changes to your body shape. For another, it will allow for a degree of personalization that will truly make your style your own. And, finally, it will just look damn good.

Focus on the Details

Been eyeing an Omega Seamaster for a while now? Maybe a pair of handmade eyeglasses? Or how about some monogrammed luggage? This is when you finally get to splurge on the accessories you always wanted when you were younger but could never afford.

Think Outside the Sneaker Box (Mostly)

Sneakers are by no means completely out of the question at this point, but they should fall into a much lighter rotation. Try a more grown-up approach to casual footwear instead—like desert boots, boat shoes, loafers, or suede derbies. And when you do lace on some sneakers, make sure to stick with either the classics—Chucks, Jack Purcells—or a nice pair of designer sneakers, like something from Tom Ford, Common Projects, or Lanvin.

It's Time for Stylish Workout Gear

You're in your forties, which means you should be engaging in a regular workout regimen. And if you're doing that, you should be dressing in proper workout gear that actually looks good. No more tattered college T-shirts and Rocky Balboa–style gray sweats. Opt for something in a low-key color that's made from a high-tech fabric. Not only will it keep you looking cool, it will also literally cool you down as well. And, as a bonus, invest in a high-quality set of headphones to help add that extra dose of musical motivation.

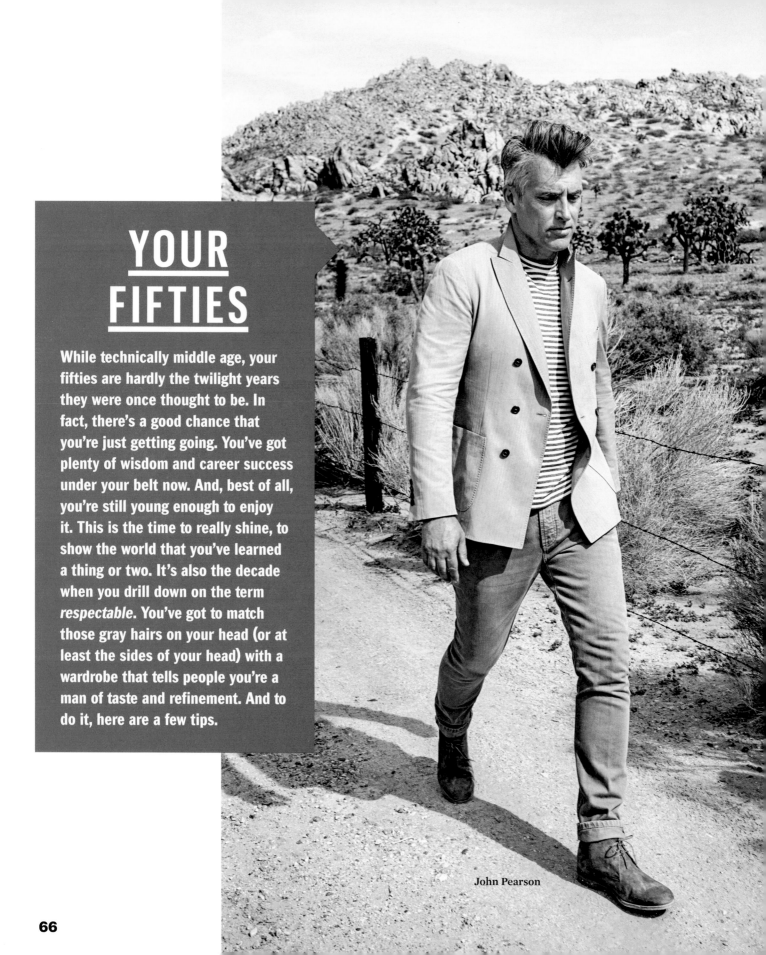

YOUR FIFTIES

While technically middle age, your fifties are hardly the twilight years they were once thought to be. In fact, there's a good chance that you're just getting going. You've got plenty of wisdom and career success under your belt now. And, best of all, you're still young enough to enjoy it. This is the time to really shine, to show the world that you've learned a thing or two. It's also the decade when you drill down on the term *respectable*. You've got to match those gray hairs on your head (or at least the sides of your head) with a wardrobe that tells people you're a man of taste and refinement. And to do it, here are a few tips.

John Pearson

Patrick Dempsey

Colin Firth

Thom Browne

Invest in the Statement Pieces You've Always Wanted

Ever dreamed of a handmade pair of bespoke Italian Oxfords? Or maybe it's a rail of custom-made suits by Savile Row's Anderson & Sheppard. How about a vintage Patek Philippe Nautilus watch? Or how about all of the above? Basically, this is the decade to turn the bulk of your wardrobe into investment pieces. A good rule of thumb: if you can afford it, you should buy it. After all, you can't take it with you, as they say, so you might as well treat yourself.

Think of This as the Era of Knitwear and Blazers

While it's possible to pull off bombers and leather jackets in your fifties, you should start to think of blazers and knitwear as your sartorial heavy lifters. Cashmere crews and merino cardigans, along with navy blazers and tweed sports jackets, are a surefire way to increase the respectability of your wardrobe. Plus, they're easy to style and won't leave you with the worry of, "can I pull this off?"

THREE THINGS YOU SHOULD OWN IN YOUR FIFTIES

A really nice watch. It doesn't have to be a $50,000 Rolex, but it should at least be something eye-catching in the four-figure range.

A really nice briefcase. Something that's made from leather and that looks like it cost you a pretty penny. Basically, something that screams, "Made it!"

Really nice cuff links. Actually, this probably qualifies as two things, since you'll also need some really nice French cuff shirts. The point being, when it's time to properly dress up, your shirt cuffs should come with some very elegant bling.

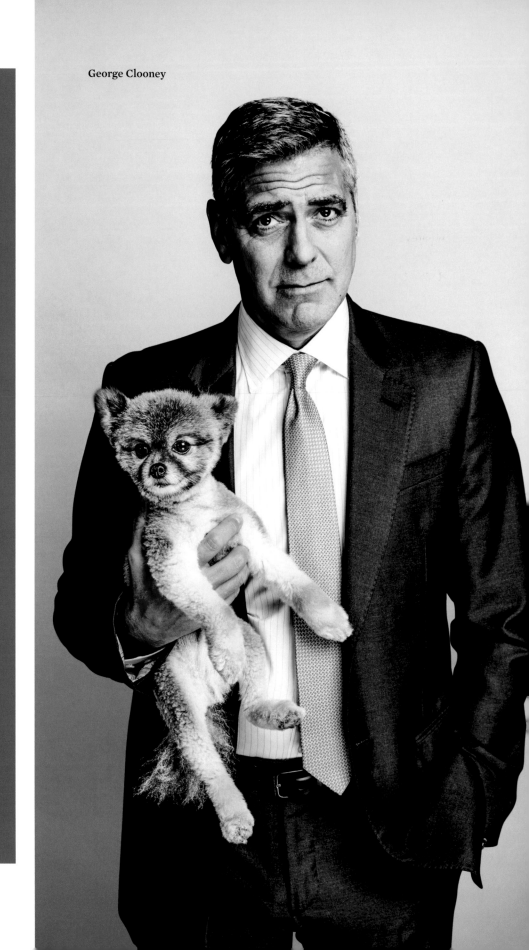

George Clooney

Be Confident

Don't freak out that you've hit the big 5-0, and definitely don't think of your life as over. If anything, you're in the prime of life. Hopefully, you've got the still-fairly-robust health to do whatever you want to do, and, most importantly, you have the funds to do it with. This is the time to really strut. Unleash the silver fox and let the good times roll.

Dark Denim Only

Just as your sneaker days are over, so too are your days of faded denim. Stick to dark indigo in a slim-ish to regular fit. Basically, the classic Levi's 501 fit should be your roadmap. And, in the summer, you're still allowed the odd dalliance with white jeans, too. Just make sure you hit that sweet spot in terms of fit. Too baggy or too slim and you're going to stand out in a bad way.

Adopt a More Harmonious Palette

Bright colors will skew too young, and pastels will skew too Florida retirement home—neither of which are ideal for a man in his fifties. Instead, opt for a more compatible color palette, with complementing shades of blue, beige, gray, camel, and dark red. If you want a pop of color, do it with a tie, a pocket square, or maybe your socks.

Update Your Suits

You've probably still got plenty of working years ahead of you. Plus, you're hopefully in the executive suite by now. This means it's now a good idea to update your suits, especially if you're still relying on a slim silhouette. The skinny suit should be a thing of the past. This is the time to go for a fuller, more traditional cut, particularly if you've added an inch or two to your waistline. That's not to say you should go baggy (never, ever do that), it's just that you want to move to a trim, two-button jacket with wider lapels and trousers and a slightly wider leg. Basically, your standard British tailoring.

Your Sneaker Days Are Probably Over

It's pretty tough to pull off sneakers at fifty, unless you're working out, of course. You can maybe swing a pair of low-top Chuck Taylors for a casual weekend look, but by and large, you should be sticking to the desert boot/boat shoe/loafer/suede Derby look you should have perfected in your FORTIES. Espadrilles are still perfectly acceptable for summer, and, of course, a nice, upscale lace-up boot will still work for winter.

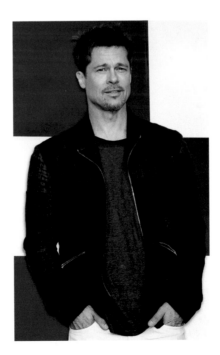

Tom Ford

Brad Pitt

YOUR SIXTIES AND BEYOND

Think of this as your era of creative elegance. Comfort has definitely moved up the ladder of importance, but it doesn't have to come at the expense of style. You can have both. The main key for looking good in your sixties and beyond is to dress well for a man your age rather than attempting to dress younger. Stick to an elegant and composed wardrobe that's suitable for your years. It'll actually make you look younger. Also, focus on high-quality materials and cuts that will both flatter and keep you comfortable. And finally, have fun. You've earned the right to pretty much do what you want now, so get a little adventurous. Be the older gentleman who outshines all those younger guns.

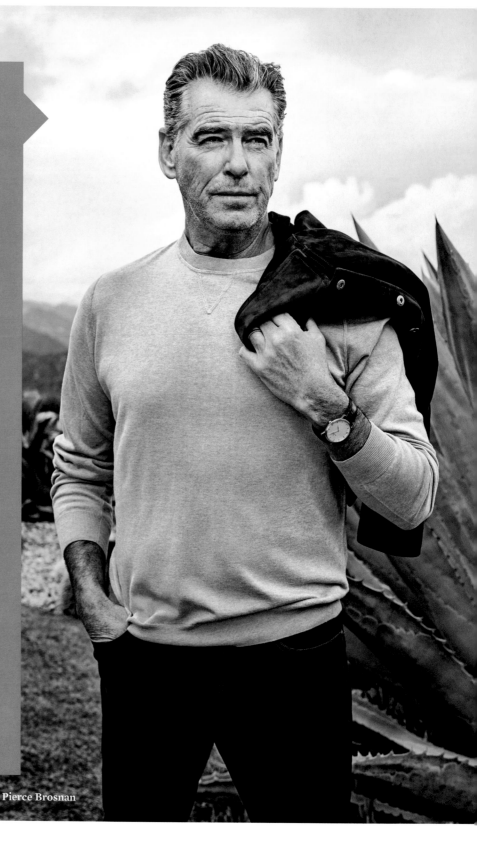

Pierce Brosnan

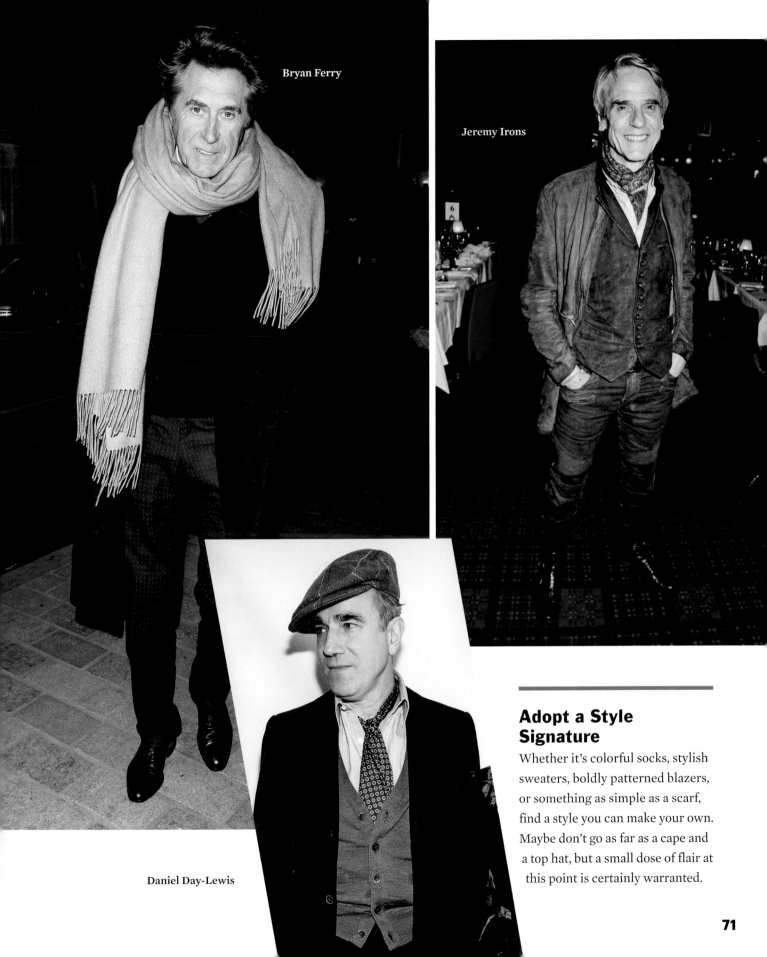

Bryan Ferry

Jeremy Irons

Adopt a Style Signature

Whether it's colorful socks, stylish sweaters, boldly patterned blazers, or something as simple as a scarf, find a style you can make your own. Maybe don't go as far as a cape and a top hat, but a small dose of flair at this point is certainly warranted.

Daniel Day-Lewis

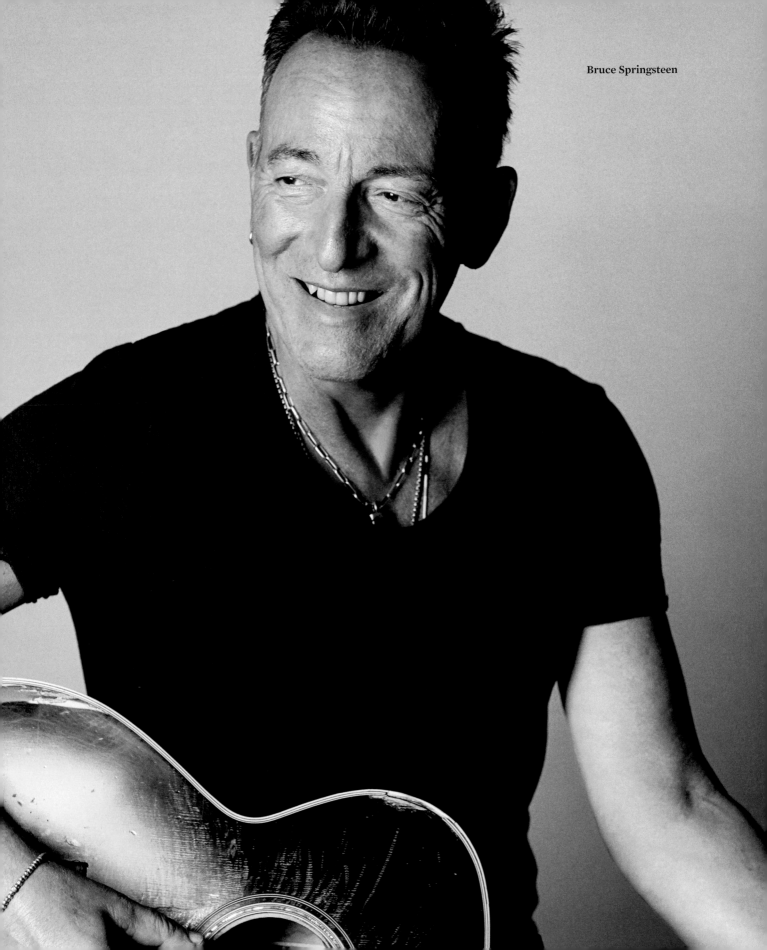

Bruce Springsteen

Tom Hanks

Get Blocky with Your Eyewear

Wire-rimmed glasses might be good for the professorial look, but as you age, you lose structure in your face. Thicker frames are a good way to combat that. You don't have to go full-on Harry Carey, just try something a little thicker in either black or tortoise shell. It will make you look distinguished.

Stick with Neutral Colors

Aside from that bit of flair, neutral colors are absolutely the way to go. Stick with soft grays, navys, camels, and browns rather than any bright colors or black. You want your color palette to soften your look to create a feeling of calm elegance.

Get Casual without Getting Sloppy

As with every other stage of life, avoiding sloppiness is mostly about cut. You're probably going to want to switch to straight-fit trousers at this point for comfort, but make sure they aren't baggy. And it wouldn't be a bad idea to skew toward polo shirts, camp collar shirts, or any other casual shirt that looks good untucked. Unless you've miraculously kept super-trim, these will flatter your shape better. And, as they're designed to be untucked, you'll still look put-together rather than unkempt.

Stick with Clothes That Have Structure

You're body is no doubt getting softer, so make up for it by choosing clothes that have structure. Blazers are an obvious choice, as they have padded shoulders. But also think about ditching T-shirts for polos and button-downs. Thanks to their seams, polos and button-downs will give a bit of shape to your shoulders. T-shirts, on the other hand, will accentuate your softness.

Gary Oldman

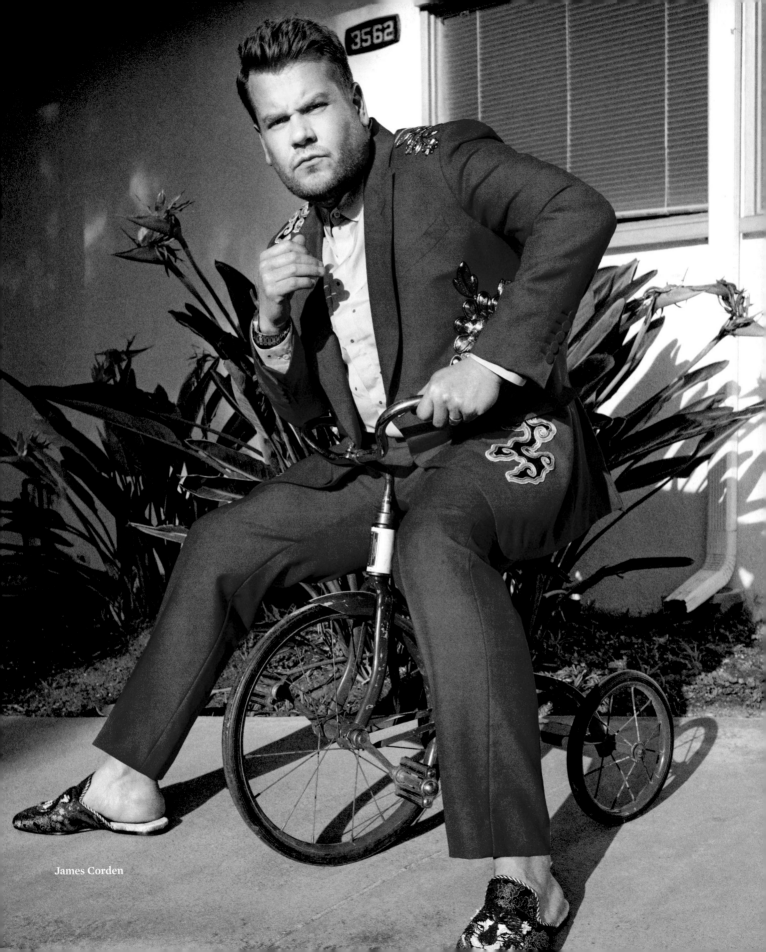

James Corden

HOW TO DRESS FOR YOUR SHAPE

NO MATTER YOUR BODY TYPE, THE RIGHT CLOTHES CAN HELP

"Clothes **MEAN NOTHING** until someone **LIVES IN THEM.**"
—MARC JACOBS

Having a solid sense of your own personal style is important. But to nail your look, it's essential to also understand how clothes fit your body. The truth is, clothes fit differently on different shapes and sizes. What might look good on someone who's tall and lean could look disastrous on someone short and stocky. And vice versa. The way clothes drape creates all sorts of different optics and angles, and understanding them is the key to not only looking good but feeling good as well. And feeling good in your clothes is what's really going to make you strut.

The first step in getting to this point, though, is figuring out your body type. With body types, there are basically five different torso shapes: triangle, oval, rectangle, trapezoid, and reverse triangle. Your shape is primarily what will dictate what you can wear, along with your height and weight. Once you understand how all these factors fit together, it's simply about sticking to a sartorial plan that best flatters your body.

HOW TO ASSESS YOUR BODY SHAPE AND WHAT WILL WORK FOR YOU

Take in your reflection.

Look in the mirror, but also look at photographs of yourself. Photographs will allow you to see yourself from angles that you can't get by looking in the mirror. And seeing yourself from multiple angles can give you a clearer picture of your true posture and proportion. Plus, the camera's eye lets you see yourself as others see you.

Know your assets.

Do you have a flat washboard stomach? Maybe it's a strong jawline or broad shoulders. Figure out what you've got going for you so that you can find clothes that will highlight those features.

Accept your flaws.

You can't wish them away, so just accept them and dress in a way that de-emphasizes them. It's actually remarkable what a good fit can hide.

Don't look with just your eyes.

It's not only about what makes you look good. It's also about what makes you feel good. Confidence can go a long way in terms of making a guy look good.

Keep an open mind.

Sometimes what you think won't work for you will actually be the thing you look best in. Don't be afraid to try new fits and styles. You never know what you'll find.

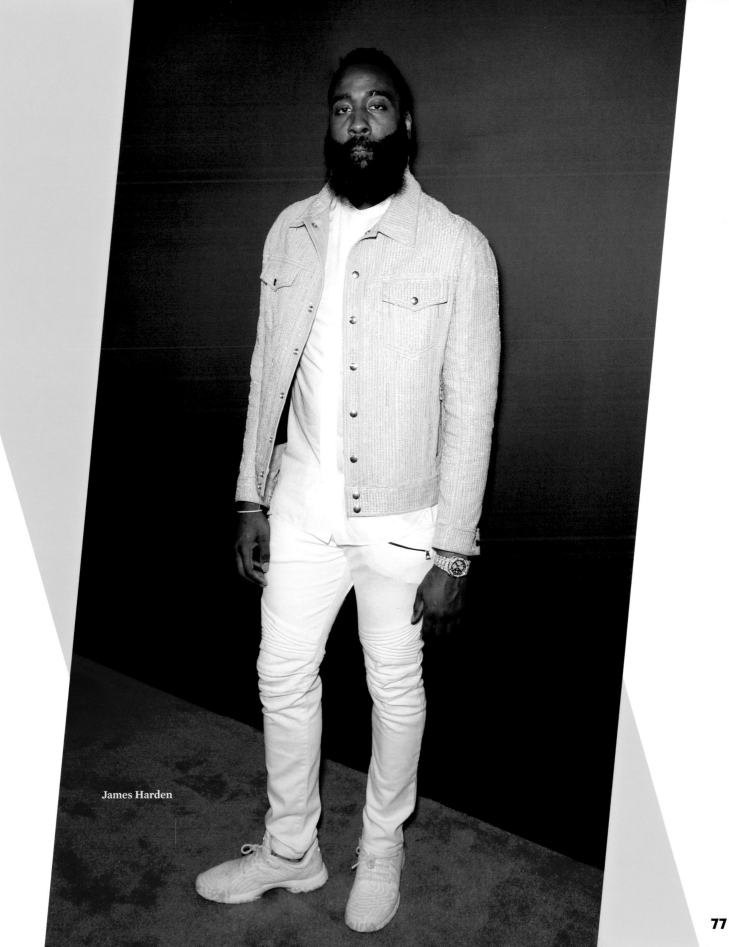

James Harden

THE OVAL

An oval shape is most common for heavier men. This is when the middle of the torso is wider than the shoulders and the hips. Men with this body shape may also have shorter, stockier arms and legs. The main key for men with an oval shape is to wear clothes that do as much slimming and lengthening as possible. Darker, simpler clothes with a bit of structure are best. Avoid anything that adds mass around the torso. Here are a few tips to keep in mind.

Wear Solids and Darker Colors

Especially if you're a bigger guy, you want to avoid visual clutter. Too much color and pattern, especially in a blazer, will draw attention to your midsection. Solids, on the other hand, especially in darker shades, will guide the eye upward, which is what you want. People should get a sense of your outfit, but they should ultimately be focusing on your face.

Suit Jackets with a Hint of Taper

Steer toward single-breasted, rather than double-breasted, and you want to avoid too much taper. A sharp taper at the waist will make the jacket look too tight and constricting when it's buttoned. Just a hint of taper, however, and it will create a subtle inward bend that frames the jacket better. This will give the illusion of a slimmer waist.

Focus on the Fit of Your Shirt

Regardless of whether you're wearing a collared shirt on its own or underneath a suit or jacket, it's crucial to make sure it fits properly. Too tight and you'll end up with all sorts of weird pinches and bulges. Too loose and it will just add volume. You want your shirt to create a clean line with no excessive bumps, pinches, or wrinkles, as it will help to slim and streamline your silhouette, even under a suit. Also, if you have a thick neck, stick to a wide collar. Narrow collars will make your neck and face look even bigger.

Trousers Should Sit at the Middle of Your Waist

For really big guys, the temptation is to let your trousers sit lower for comfort. The problem is, this will cause your belly to spill over, creating a very unflattering visual effect. Instead, make sure your trousers are tailored to fit comfortably around the middle of your waist—not too high, you want them below your navel—so that they create more of a clean line in the transition from trousers to shirt.

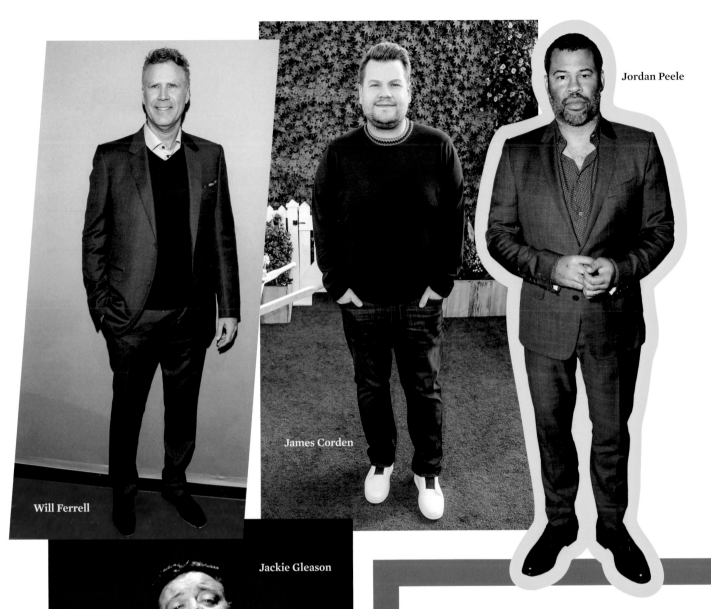

Will Ferrell

James Corden

Jordan Peele

Jackie Gleason

STYLES TO AVOID

Tight fits. If you're hoping that by pouring yourself into a tight jacket or shirt you'll look slimmer, you're going to be sorely disappointed. That's just going to emphasize your size. It will also look kind of desperate. Your clothes should work with you and not against you. Better to trick the eye with a clean line rather than treat your jacket like a girdle.

THE RECTANGLE

Men with a rectangular torso shape tend to be taller and thinner. Basically, your hips are the same width as your shoulders, so your body is just two parallel lines running down either side. With this body type, you want clothes that widen your shoulders a bit to give you a more tapered shape. This will help create an illusion of a less boxy frame, which is an important element in flattering leaner body types. Here are some things to focus on.

Horizontal Stripes

If you're a super-slim guy, a horizontally striped shirt—like a Breton tee—will add a bit of width to your shoulders and torso, which will help you appear more proportional. Anything that builds out the top portion of your frame, either physically or optically, is good.

Structured Tailoring

If you happen to be really skinny, this can definitely improve your proportions. You want to add just a little bulk to your shoulders to get that ideal, tapered silhouette. And single-breasted is better for this body type, as it will nip in your waist to give your torso more of a taper. But, truthfully, structured tailoring benefits nearly every body type.

Prints, Colors, and Patterns

If your body type falls into the rectangular category, you can pretty much wear any print, color, or pattern. Bold-print camp collar shirts, brightly colored jackets, bold patterned suits—all of these will help to expand the dimensions of your slim frame.

Layer Up

Visually, you need to add bulk to your upper body, and layering is a great way to do it. Any sort of multiple layers will do—a cardigan and a tee, a crew-neck sweater and a button-down, a polo shirt and a bomber. It is the sartorial version of chest-and-shoulder day at the gym.

STYLES TO AVOID

Double-breasted jackets. It's not an absolute no-fly zone, but a DB jacket, because of its rectangular cut, won't help you out in terms of creating that much-needed tapering effect. If you do wear one, make sure it has structure in the shoulder. An unstructured double-breasted jacket with a rectangular frame is a hard no.

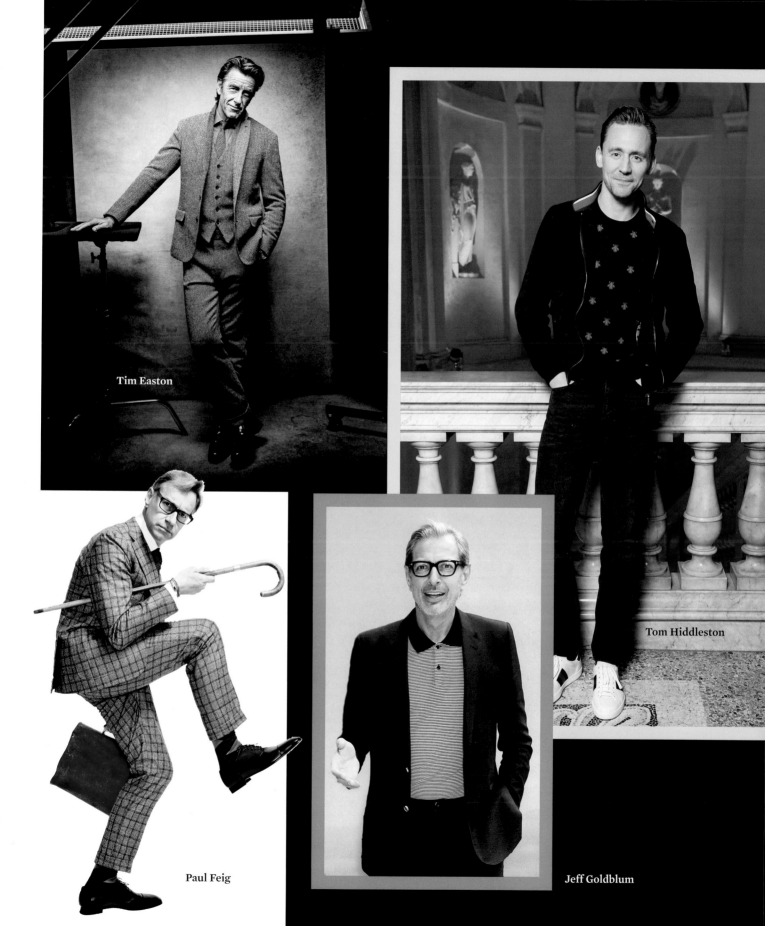

Tim Easton

Tom Hiddleston

Paul Feig

Jeff Goldblum

THE REGULAR

The best way to understand this body shape is to recognize that it's considered an "average" build. You're slim but not super-skinny. And your shoulders, while they aren't super-wide, are at least wider than your waist. The good news is that this is the easiest body type to find clothes for. And it's also the most naturally flattering. You're slim enough to look good in most fits, patterns, and colors, and, most importantly, you have wide enough shoulders that your body naturally tapers. With this body shape, you're mainly looking for clothes that highlight your physique. Here are some ways to do it.

Slim, Not Skinny, Fits

May as well flaunt it if you've got it. But don't go super-skinny unless you also happen to *be* super-skinny. With a slim rather than skinny body type, super-skinny clothes will actually make you look thicker. You want clothes that graze your body, not cling to it. Clothes that graze your naturally trim and tapered physique will flatter it. Clothes that cling to it will make you look bulgy, negating the visual benefits of actually being trim.

Patterned Shirts

When it comes to patterns, you can wear almost anything. One thing to keep in mind, though, is which pattern will best complement your height. If you're a little bit shorter, vertical stripes will help you look taller. If you're a bit taller, go with checks and plaids; they will add a bit of horizontal bulk to help emphasize your tapered silhouette.

Slim and Slightly Tapered Trousers

These will add length to your legs, which will make you look taller. And if you're already fairly tall, it's still a good fit to favor since it will add balance to your overall frame.

STYLES TO AVOID

Actually, there isn't much you can't wear. Saggy and baggy clothes should be avoided, mainly because they won't showcase your trim build. If you're looking for clothes that accentuate your naturally proportional physique, stick with clean lines and crisper fits.

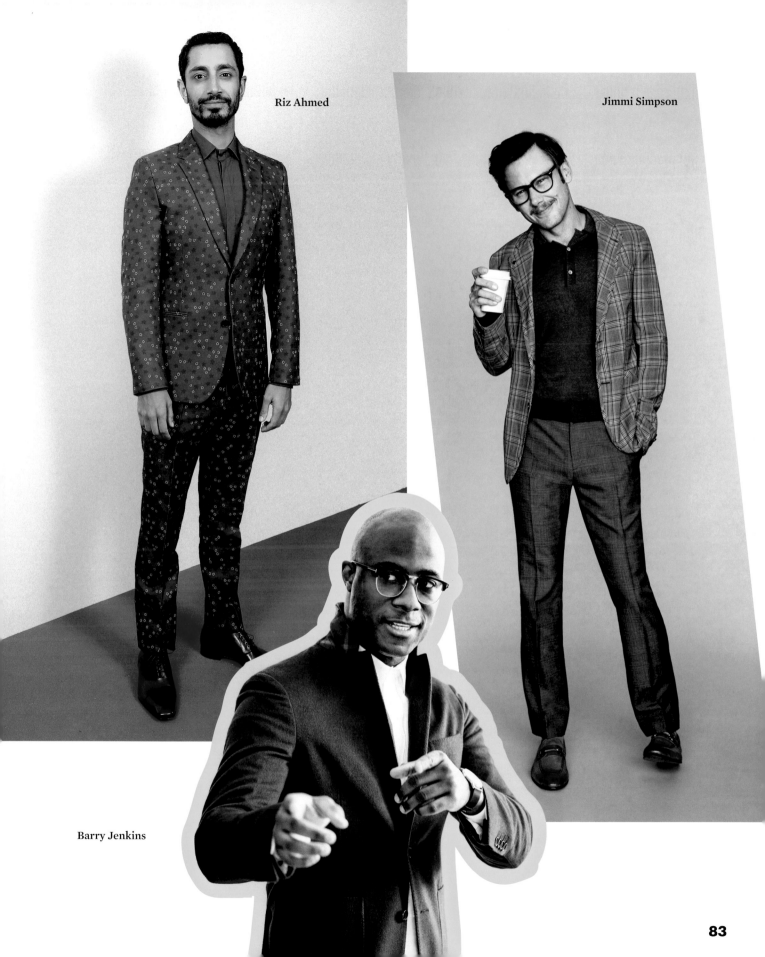

Riz Ahmed

Jimmi Simpson

Barry Jenkins

THE TRIANGLE

A triangle body shape, aka the comic book superhero frame, is where your shoulders are super-wide and your waist is super-narrow. You also likely have a well-developed chest and upper back and probably some pretty ripped arms, too. If this is you, kudos to you for all your hard work in the gym. Just keep in mind that, with a well-developed chest and shoulders, not to mention a narrow waist, you're going to want to stick with clothes that keep you from looking too top-heavy. Sure, you may be proud of all that bulk, but you don't want to look like you're perpetually about to tip over. Here are a few tips to steer you away from any style disasters.

Slim-Fit Rather Than Tight

The difference between these fits is an easy line to cross. If you can see muscle definition through your shirt, pants, or suit, the item is too tight. Instead, size up and rely on the construction of the garment to highlight your stacked frame. You want your clothes to show a subtle hint of your fitness, not look like Superman's onesie.

Choose Unstructured Tailoring

You've already got all the structure you need in your physique. Anything more and you'll look like you're wearing football shoulder pads. Also, make sure your jacket isn't too tight. You'll end up with a look best described as "bulge-y," which is not an adjective you want in a suit. A softer shoulder that follows the line of your natural silhouette will work best.

Go for Straight or Slightly Tapered Pants and Jeans

Resist the temptation to go towards skinny. If you've got a bulky upper body, skinny jeans will make your legs look tiny and cartoonish. People will think you skipped leg day for the last decade. Slim, straight-ish pants and jeans will help even out your proportions, which will make you look taller.

Look for Trousers with a Larger Seat Drop

The seat drop is the measurement between the waist and the crotch seam. For bulkier guys, standard sizing on drops can get a little snug in the groin area. Trousers specifically made with a larger drop will allow for more room, which will be more comfortable and won't cause any weird bunching or pulling.

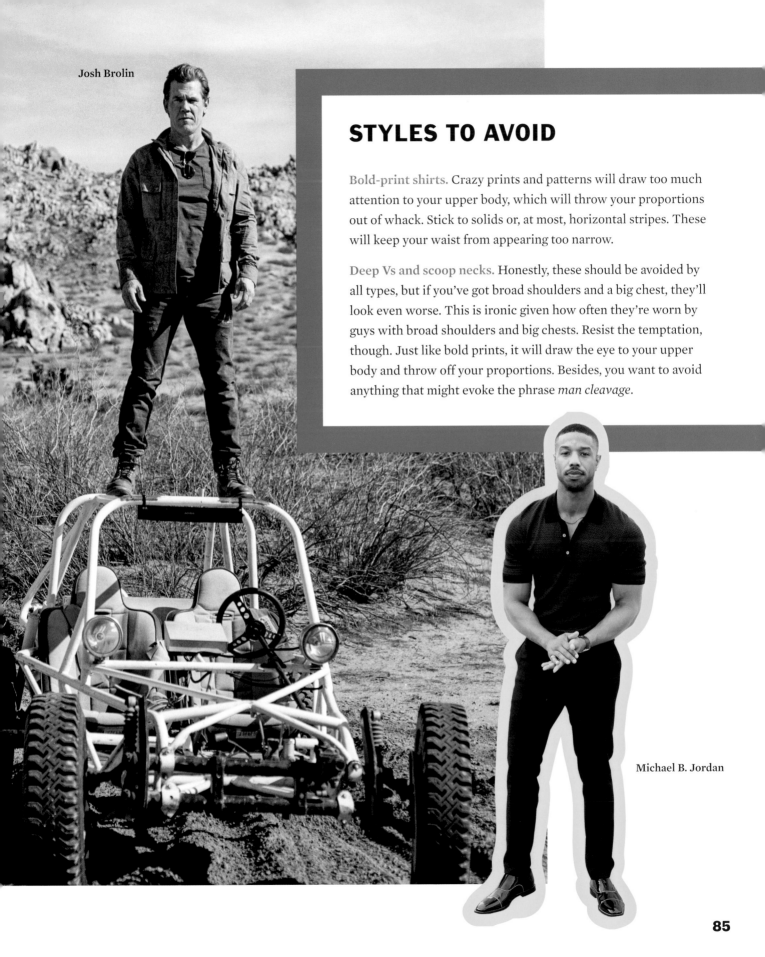

Josh Brolin

STYLES TO AVOID

Bold-print shirts. Crazy prints and patterns will draw too much attention to your upper body, which will throw your proportions out of whack. Stick to solids or, at most, horizontal stripes. These will keep your waist from appearing too narrow.

Deep Vs and scoop necks. Honestly, these should be avoided by all types, but if you've got broad shoulders and a big chest, they'll look even worse. This is ironic given how often they're worn by guys with broad shoulders and big chests. Resist the temptation, though. Just like bold prints, it will draw the eye to your upper body and throw off your proportions. Besides, you want to avoid anything that might evoke the phrase *man cleavage*.

Michael B. Jordan

THE SHORT GUY

When it comes to your clothes, the good news is that height is all about perception. Wear the right outfit and, unless someone is standing right next to you, they'll never know how short you really are. In fact, the right clothes can actually make you look taller. Even better, they can make you feel taller, which will give you a shot of confidence that'll work better than any heightening trick. It's certainly worked for the famously small-statured Tom Cruise. And as far as style goes, height is irrelevant. Super-stylish guys like Daniel Radcliffe, Kendrick Lamar, and Pharrell Williams—none of whom break 5-foot-9—are proof of that. So, if you're on the shorter side, here are a few tips to make your clothes work for you.

Go Monochrome

A monochromatic color scheme—where you contrast shades, rather than colors—will streamline your look and help create the illusion of height. And the darker the better, although not black. Black will actually make you look shorter. If you mix shades—and this is true of mixing colors as well—go darker on the lower half of your body and lighter up top. This creates a lengthening effect by drawing the eye upward.

Find a Good Tailor

Fit is everything when it comes to looking taller, and a good tailor will know how to accentuate the right lines and hide the bad ones. Off-the-rack clothes tend to be boxier to fit a broader range of body types, so you're going to need a lot of tailoring to get that illusion of height. With a good tailor, you can bring in those boxy clothes, tell him you want to look slim and tall, and he'll take care of the rest.

Avoid Baggy, Low-Waisted Trousers

Saggy drawers are never a good look, but they're even worse if you're short. Instead, make sure the waist of your trousers sits at your natural waistline. This will maximize the length of your leg line, and the appearance of having longer legs is a major factor in looking taller. Also, stick with a slimmer trouser and a smaller rise. This, too, will make your legs look longer.

Don't Let Your Shirt Hem Pass Your Hip Bone

As a short guy, you should probably be tucking your shirt in 90 percent of the time. It's another trick to make your legs look longer and your body look slimmer. But for the 10 percent of the time that you go untucked (if you're wearing a shirt designed to be untucked, like a camp collar shirt or a T-shirt), make sure the hem doesn't go past your hip bone. Anything longer and it'll make your legs look stubby.

Jonah Hill

Pablo Picasso

Dudley Moore

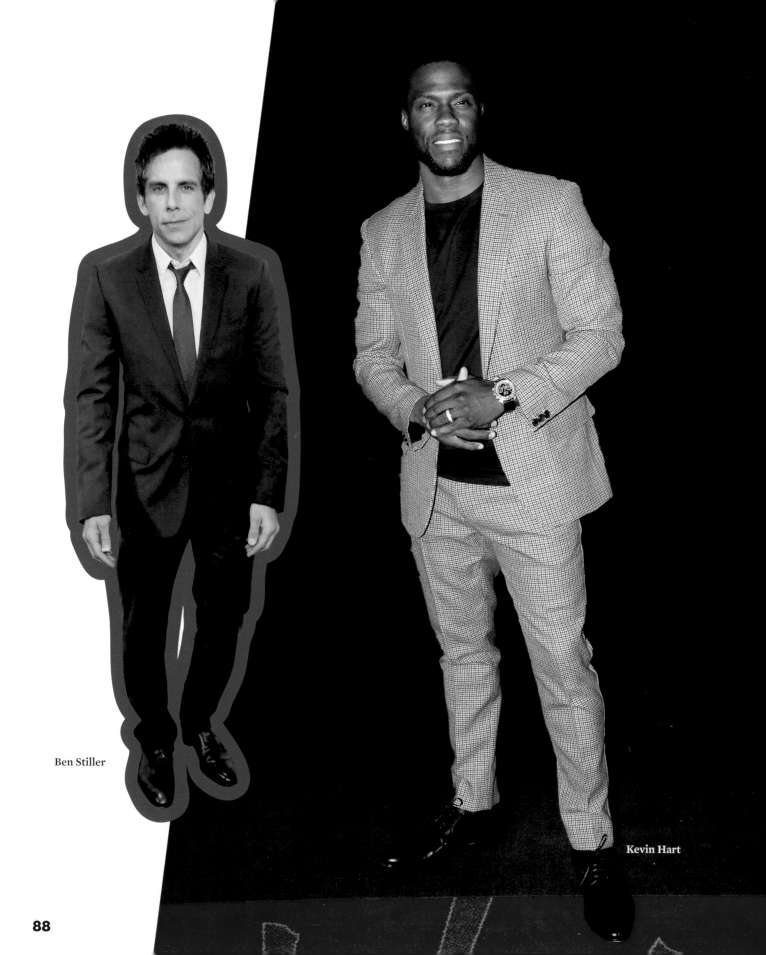

Ben Stiller

Kevin Hart

Daniel Radcliffe

A Blazer Is Your Best Friend

A well-tailored, slim-fitting blazer or suit jacket will help build up your shoulders, which adds to the illusion of height. And make sure to keep your jacket buttoned (top button on a two-button, middle button on a three-button), as this will slim your silhouette while making your shoulders appear bigger, both of which create a heightening effect. And, finally, make sure the top button of your jacket is a little above your navel to make your torso and legs look longer.

STYLES TO AVOID

Short Sleeves. This is a hard pill to swallow during the dog days of summer, but the simple fact is that a short-sleeve shirt creates an optical illusion that shortens your arms. And if your arms look short, so will the rest of you. One workaround is to wear a long-sleeve shirt and then roll up the sleeves. This will create an unimpeded line, whereas the flare of a short sleeve creates a broken line, which you don't want. So a long-sleeve shirt with the sleeves rolled up will make your arms, and, as a result, the rest of you, look longer.

Accessories Below the Waist. One trick to looking taller is to get the person who's looking at you to sweep their eyes upward. It will make whatever they are looking at appear taller. Avoid wearing anything that will draw their attention below your chest, like flashy shoes, flashy watches, or big belt buckles. If you absolutely have to have some panache, maybe just go for a colorful pocket square. Or, better yet, some stylish eyewear.

THE TALL GUY

In general, taller men just need to find clothes that fit properly. Off-the-rack can be a bit tricky if you're really tall, so it's important to have a good tailor who can make adjustments for your size. Other than that, as long as your clothes fit properly, there's not a whole lot you can't do. This is a pretty big bonus in terms of being creative and having fun with your style. However, here are a few things to consider.

Be Careful with Prints and Patterns

The taller you are, the smaller your patterns should be. Too big and crazy and they'll overwhelm the person looking at you. With stripes, make sure to keep those fairly slim, like pinstripes. And if you do want to go a little bit bolder with your pattern, just dial down the color to make up for it. Blues, blacks, and grays that complement one another are the best way to go.

Bespoke Is Best

If you're super-tall and can afford it, getting clothes made for you is the best thing you can do. This way you won't have to make compromises on fit (like wearing something that's wider just because it's the only thing long enough), and you can get exactly what you want. There are even some bespoke tailors out there who can copy existing styles, so if you want to follow the trends, you can.

Avoid Bulky Shoes

This is especially true for tall, slimmer guys. You want shoes that keep you proportional, and bulky shoes can throw your proportions out of whack by making you look like a giant "L." Stick to shoes that are sleeker, narrower, and have a slimmer sole. Also, the slimmer the cut of your trousers or jeans, the sleeker your shoes should be.

Find Brands That Work for You

This is the most difficult part of being really tall. Some brands do a great job of catering to taller guys, while other brands apparently forget they exist. To find the right brands, you just have to try on a lot of clothes. Unfortunately, this makes shopping online hard, at least initially, but once you know which brands work for you and which of their sizes fit, it'll get easier.

Give Them a Break

Your trouser hems that is. On a tall guy, trousers with no break (meaning the hem only grazes his shoes) can look too short. A little bit of break, however, about an inch or so, creates a better, more natural line. This makes the trousers look like they fit you properly and not like you were stuck with something too small.

Willie Geist

Armie Hammer

LeBron James

UNIVERSALLY FLATTERING PIECES

Skinny, stout, tall, or short—these are the clothes that will look great no matter what your body type.

Flat-Front Pants

In terms of pants that flatter the most body types, flat front is king. Some might think that pleated trousers, with their increased room in the seat, would be better. But that extra room is actually their downfall. It creates an effect that makes the wearer look wider. Flat-front trousers, on the other hand, have a clean line that creates a slimming effect.

A Classic Solid Oxford Shirt

Whether white, blue, or something more bold, a solid Oxford is one of the most universally flattering shirts you can own. The thicker Oxford cloth helps hide any unsightly bumps and bulges, while the seam at the shoulder adds structure. Plus, the button-down collar, worn open at the neck or with a tie, will flatter just about any neck type—short, long, thick, or skinny.

A Two-Button Navy Blazer

As we've mentioned before, quality tailoring flatters every man. And a two-button navy blazer or suit jacket is the apex of that flattery. The fit slims the silhouette while the shoulder—structured for most guys, but unstructured for the athletic type—creates a balanced proportion. Plus, the dark tone of navy creates a slimming and lengthening effect.

A Trench Coat

In terms of flattering outerwear, it's impossible to beat the classic double-breasted trench coat. The structured design and stiffer fabric hides just about any flaws, while the tapered-at-the-waist cut slims and lengthens. Plus, you can always wear it belted to help further define your waist. And, maybe most importantly, it will go with just about anything in your closet.

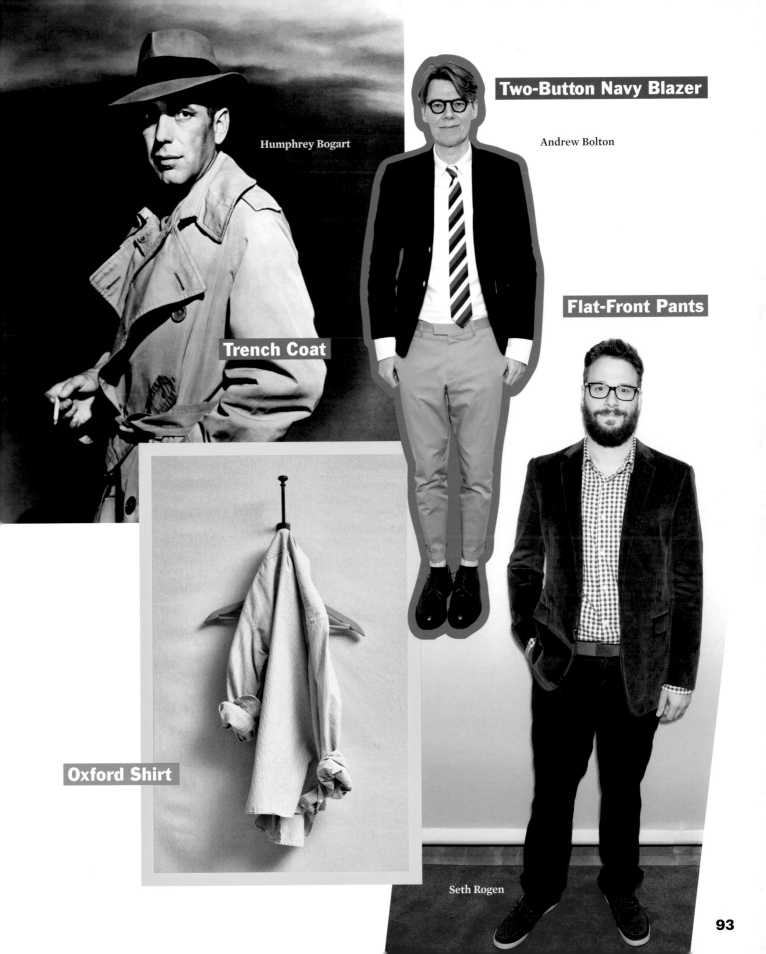

Trench Coat

Humphrey Bogart

Two-Button Navy Blazer

Andrew Bolton

Flat-Front Pants

Oxford Shirt

Seth Rogen

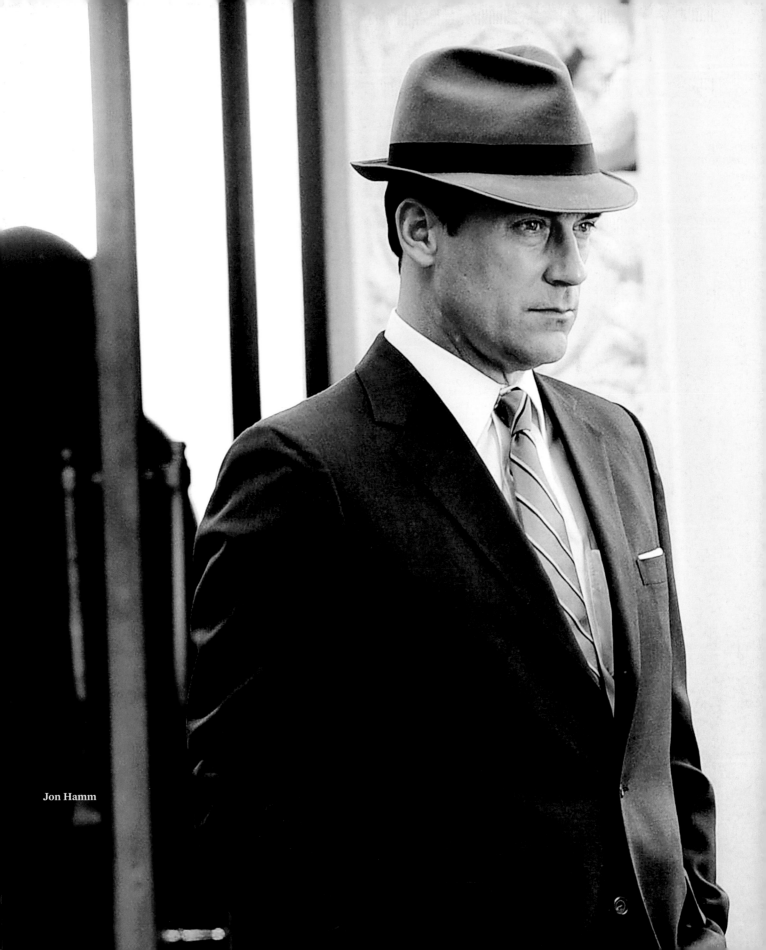

Jon Hamm

OFFICE STYLE

YOU SPEND MOST OF YOUR LIFE AT WORK; HERE'S HOW TO DRESS FOR IT

"Fashion is the **ARMOR TO SURVIVE** the **REALITY** of everyday **LIFE**."

—BILL CUNNINGHAM

Maybe your office is a suits-only establishment. Or maybe you work in a sea of graphic tees and hoodies. More likely, you're dealing with something in between. Whatever your office dress code, it's important to find clothes that make you look put together—outfits that let people know they're working with a real professional. After all, if clothes tell a story, your sartorial story should be something along the lines of, "I'm a guy who gets things done."

continues »

Left to right: Tyson Beckford, Bruce Hulse, and Tim Easton

« continued from previous page

But of course, with so much variation in office dress codes, it's hard to know what constitutes "professional." When your CEO is known for his daily uniform of gray hoodies, it can be a little bit subjective. The best way to approach it is to divide your work environment into one of three categories: formal, business casual, or casual. For a formal office, the dress code is easy—suits and ties every day. Business casual is a bit trickier, as it's more open to interpretation and can include anything from chinos and a crisp Oxford to dark jeans and an upscale tee. And as for casual, the main thing to understand is that there's a difference between "work casual" and "home casual." Once you've got that all sorted, it's simply about putting together the right looks to ensure you're the best-dressed man at your office.

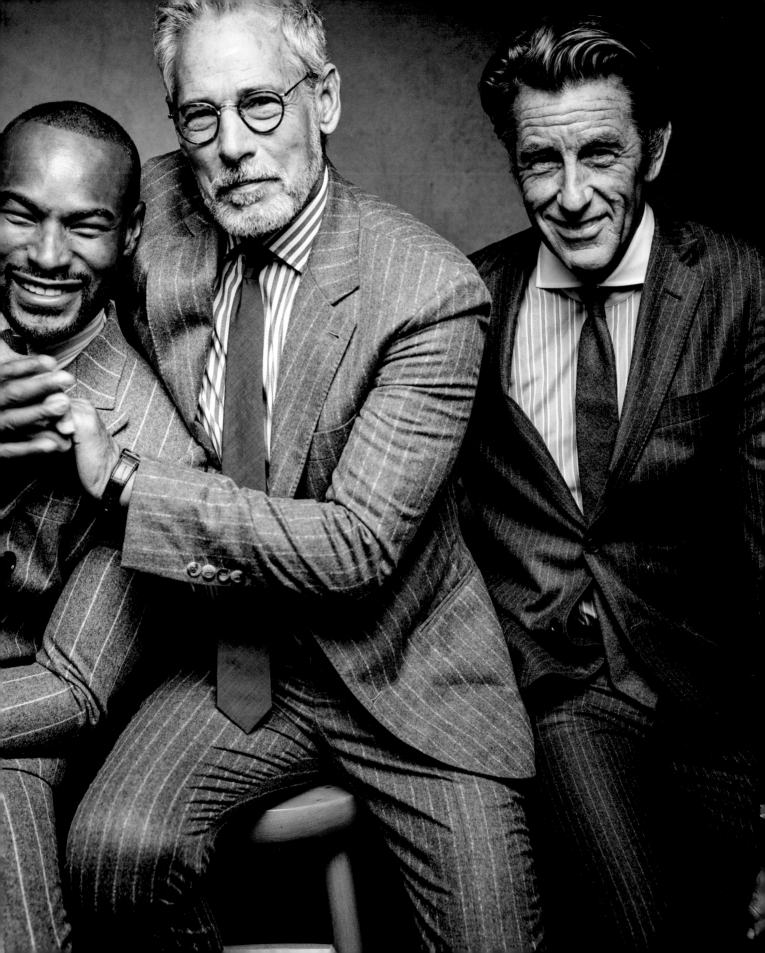

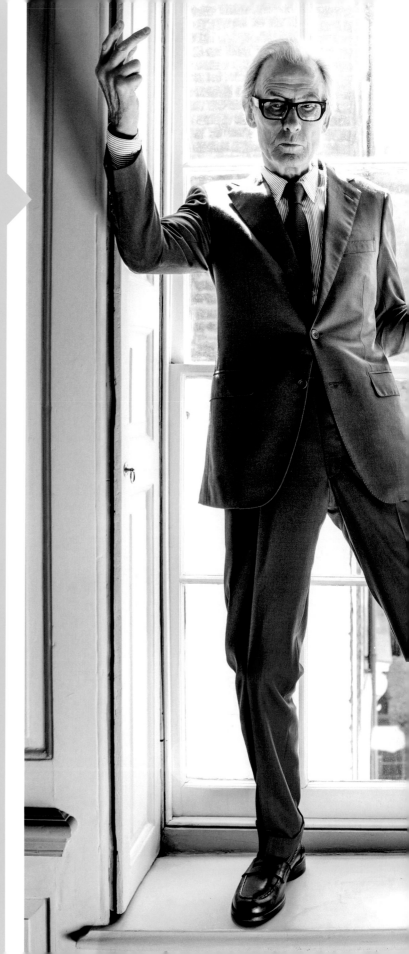

7 OFFICE MUST HAVES NO MATTER WHAT THE DRESS CODE

Regardless of what category your office falls into, make sure you always have a few key pieces at your disposal. After all, you never know when an important meeting with a new client or lunch with the boss might come up. Even in a fairly casual environment, the odd occasion may arise when you'll need to spruce up your look and dress to impress. To ensure that you're never caught off guard, here are seven essentials to keep in your closet to cover any professional setting.

Bill Nighy

❶ A Navy or Charcoal Suit

Even Mark Zuckerberg wears a suit every once in a while (at least, whenever Congress comes calling). A single-breasted, two-button navy or charcoal suit is perfect for even the most conservative offices.

❷ A Navy Blazer

Throw a well-tailored navy blazer over almost anything, including a T-shirt, and it'll add polish to your look. Ideal for any last-minute lunches or meetings.

❸ A White Dress Shirt

In terms of dress shirts, classic white is the most traditional, but more importantly, it's the most versatile. You won't have to worry about whether your suit or tie matches it because a white shirt matches everything.

❹ Black Oxfords

Any time you need a more formal look, this is the shoe to choose. It's by far the dressiest and most versatile, plus you can dress them down with dark jeans or chinos for anything less formal.

❺ An Elegant Sweater

If you need a more polished look that isn't as formal as a suit or blazer, a fine-knit crew-neck sweater—preferably in a soft yarn like cashmere or merino—is the answer. Stick to a darker color, like navy or gray, for optimum versatility, and wear it over a tee or a collared shirt, whichever you prefer.

❻ Chinos

You can dress them up with a blazer or down with a polo or T-shirt. Plus, they're a little bit more polished than jeans.

❼ A Conservative Tie

You never know when you're going to have to upgrade your look for a meeting, so it's a good idea to always have a tie on hand. Something conservative—solid, or maybe a striped club tie—and in a fairly neutral color like navy, gray, or dark red so that it will match whatever you're wearing.

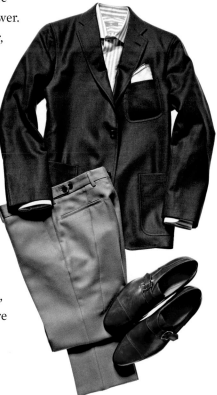

THE FORMAL OFFICE

It is certainly less common these days, but there are still plenty of work environments where a suit and tie is the only acceptable form of dress. Think law offices, political offices, and investment banks. The upside to a suit-and-tie-only setting is that it narrows your parameters, which makes it a lot easier to get dressed in the morning. The downside is that you have less room to show off any personal style. But that doesn't mean you can't add the odd touch here and there. Stick to these guidelines and you'll nail not only the professional portion of the program, but also the style portion.

Tom Hardy

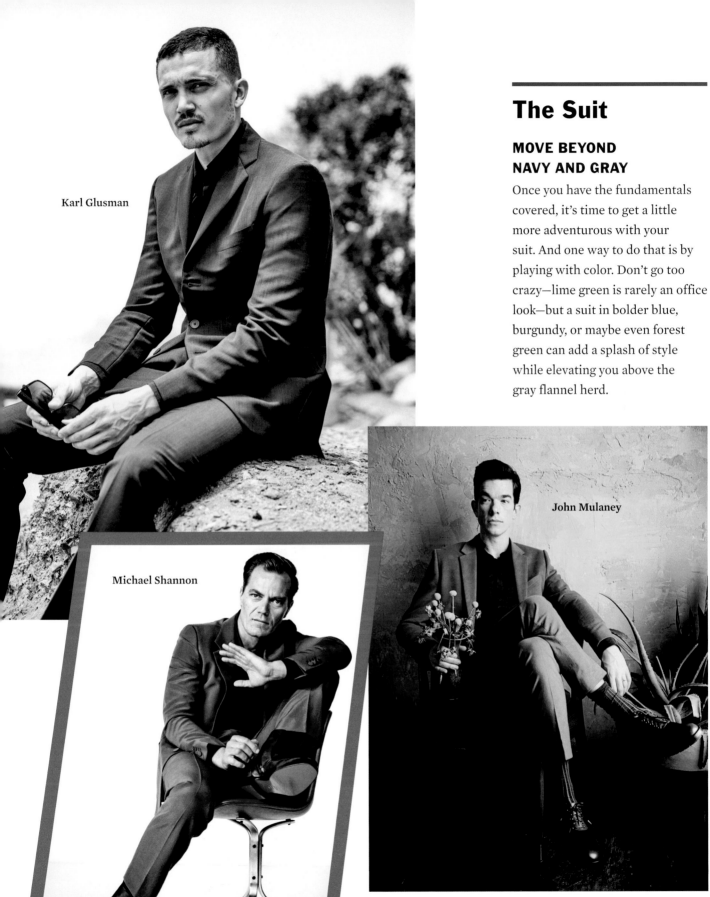

Karl Glusman

Michael Shannon

John Mulaney

The Suit

MOVE BEYOND
NAVY AND GRAY

Once you have the fundamentals
covered, it's time to get a little
more adventurous with your
suit. And one way to do that is by
playing with color. Don't go too
crazy—lime green is rarely an office
look—but a suit in bolder blue,
burgundy, or maybe even forest
green can add a splash of style
while elevating you above the
gray flannel herd.

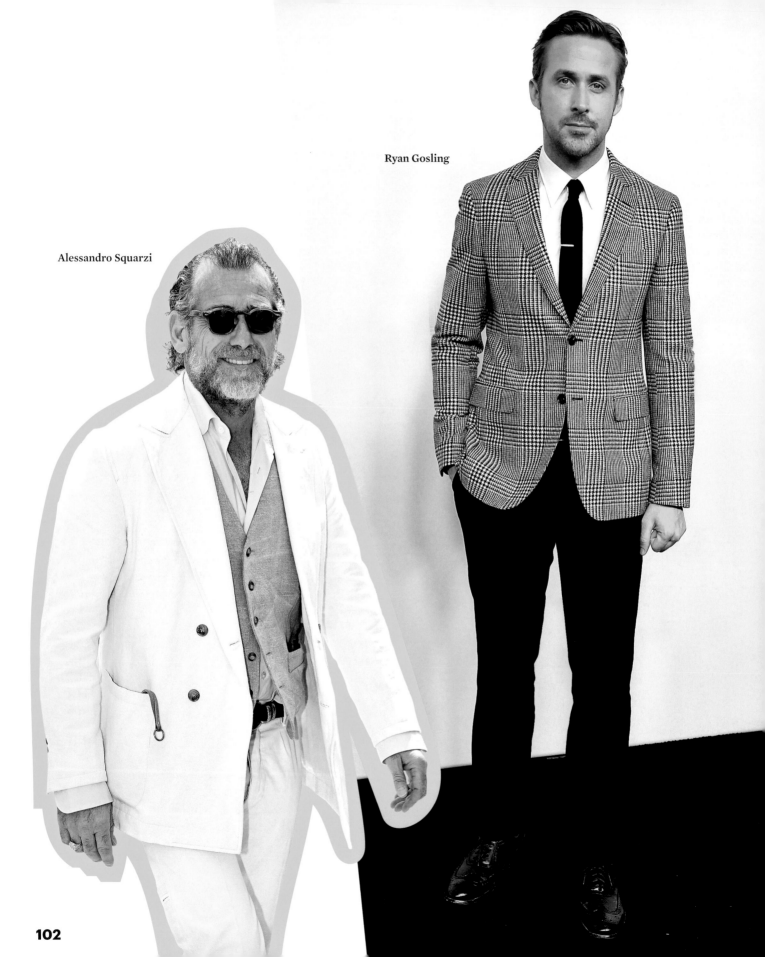

Alessandro Squarzi

Ryan Gosling

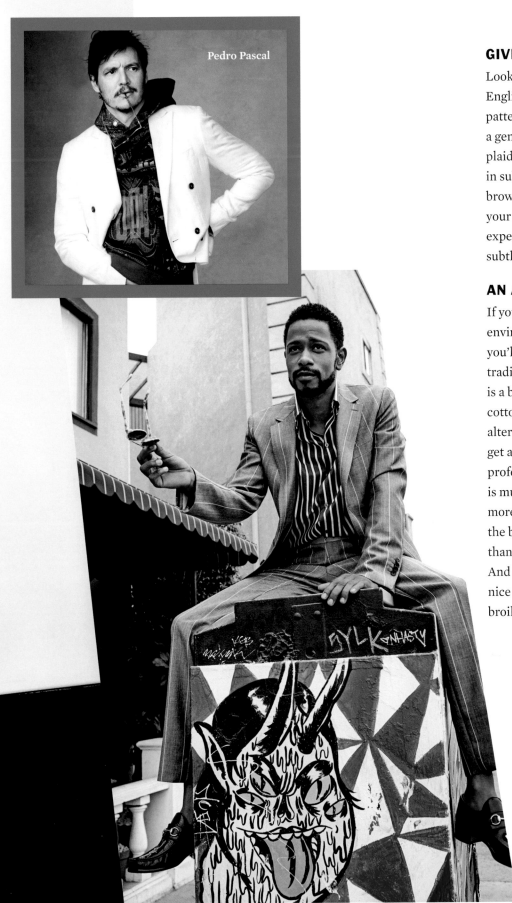

Pedro Pascal

Lakeith Stanfield

GIVE PATTERNS A TRY

Look no further than classic English tailoring to see that patterns have long been part of a gentleman's wardrobe. A Glen plaid or a Prince of Wales check in subtler shades of blue, gray, or brown is the obvious choice. But if your office allows for a little more experimentation, try combining a subtle pattern with a bolder color.

AN ALTERNATIVE TO WOOL

If you work in an office environment that requires a suit, you'll most likely need to stick to traditional wool. But, if your boss is a bit more sartorially lenient, a cotton suit can be a great summer alternative. With cotton, you get a crisp line that keeps things professional—unlike linen, which is much softer and skews a bit more casual. Plus, you also get the benefit of it being a bit cooler than non–tropical weight wool. And a lighter shade can add a nice seasonal touch during those broiling-hot summer days.

MIX AND MATCH

Depending on your office, it might be okay to add a little depth to your outfit by mixing and matching suit separates—that is, a blazer or suit jacket with a mismatched pair of trousers. The easiest way to pull this off is to pair a navy blazer with gray trousers. But you can also try mixing a tweed or patterned blazer with solid trousers or even pairing up two different shades of blue or gray. Just steer clear of combining anything with black; in tailoring, at least, it's a color that doesn't play well with others.

The Tie

Not too skinny, not too fat. For the office, the ideal tie width is between 2.75 and 3.15 inches. Yes, skinnier ties were all the rage for a while, and in some circles fatter ties have gained traction, but in terms of maintaining a professional look, it's always best to shoot for the middle ground. Dandy and rocker are probably not descriptors you want attached to you when you work at an investment firm.

MIX COLORS AND PATTERNS

Matching your tie to your outfit is a combination of art and science. But to get your artistic flair right, you need to know the scientific principles.

Tom Wolfe

You can get away with a busier tie pattern—not novelty-busy; think checks, plaids, or paisleys—if your shirt is solid white or light blue. With a darker or bolder- colored or -patterned shirt, dial down the pattern and color of your tie.

When you match the color of your tie with your shirt, go with the secondary color in your tie. For instance, if it's a blue tie with a small pink and red paisley pattern, match the pink or red rather than the blue.

Mixing patterned shirts with patterned ties is absolutely okay. The key to pulling this off is scale. You want to match a bigger pattern with a smaller one. For example, if you're wearing a shirt with a small check pattern, complement it with a bold-striped tie. If, on the other hand, you have a bold madras-print shirt, choose a tie with a smaller pattern on it, like a pin dot. And don't match similar tones. Make one a lighter tone and one darker.

The Shoes

OXFORDS VERSUS WING TIPS

In terms of dress shoe choice, the important thing to understand is that the plain or cap-toe Oxford is the more formal look, while the wing tip is slightly more casual. That said, in 90 percent of office situations, either will be acceptable. But if you happen to work in a place that's extremely conservative, the Oxford is the better choice.

THE POWER OF SUEDE

While a wing tip is a great way to add visual texture to your suited office look, an even bolder choice, assuming it's kosher with the boss, is a suede wing tip or Derby. Suede definitely skews more casual, but as long as you pair it with a crisp suit and tie, it can definitely add a pinch of nattiness to your otherwise traditional look.

Mark Cho

The Accessories

POCKET SQUARES

A pocket square can be a great way to add a little pop to a suit or blazer, especially if you work in a more traditional setting that limits your color choices. Just remember that, for the office, it's best to stick to either a classic fold or a single-peak triangle. Anything more than that—triple peaks, roses, exploding flowers, etc.—and it can come off as a little too jaunty.

WRIST BLING

The two avenues for decking out your wrist are watches and cuff links. With watches, you have a pretty wide berth in terms of what you can wear. Even in the most conservative of offices, statement watches are often acceptable. With cuff links, however, you probably want to keep things more low-key. Nothing too flashy or ostentatious, and definitely nothing joke-y. And, with all due respect to George Costanza, make sure you have on a French cuff shirt when you wear them.

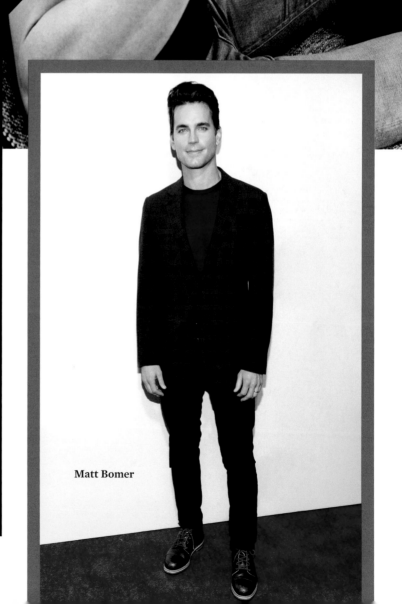

Jon Bernthal

THE BUSINESS CASUAL OFFICE

These days, business casual is very common when it comes to office attire. The biggest problem with this style of dress, however, is that it can be hard to pin down. Are jeans okay? What about sneakers? Is a suit going to stand out too much? Ultimately, there are a couple of ways to approach business casual that will help ensure that you always hit the sweet spot. Just remember, when in doubt, it's better to be overdressed than underdressed. Here are some tips that will get you sorted.

Matt Bomer

Think High/Low

One way to excel at business casual is to mix higher, more formal pieces with more casual clothes. The best example of this is jeans and a crisp, structured blazer. The high of the blazer keeps you from looking too casual, while the low keeps you from veering too formal. It strikes the perfect balance. Another example would be tailored trousers, a crew-neck sweater, and clean, minimalist sneakers. In fact, including one piece of tailoring in your business casual outfit is generally a good approach all around.

It's All About the Right Shoes

One area where you can add a splash of personality to your office look is with your shoes. That's not to say that you should roll in wearing studded combat boots. You can certainly mix it up a bit with desert boots, suede Derby shoes, loafers, brogues, or even an old-school pair of saddle shoes. A little imagination with your footwear and you can completely transform your look.

Fit Is Key

This is the most important element of your office look, regardless of dress code, but it's especially true of business casual. A perfectly fitting crew-neck sweater and chinos will strike the ideal professional chord. On the other hand, should those same elements be ill-fitting—pants too long and baggy, sweater bunching up in all the wrong places—it will make you look frumpy and underdressed. Think about it this way: focus on fit and you can get away with a lot more in terms of *what* you wear.

Bruce Hulse

Sneakers at the Office

Yes, sneakers can work for business casual, but only to a limited degree. They need to be low-profile and low-key and preferably a solid color scheme—all white, gray, beige, etc. Brightly colored chunky basketball sneakers will be almost impossible to make look professional. And the best way to wear sneakers is with a suit or maybe dark indigo jeans and a navy blazer. Essentially, your clothes should skew more "business," since your sneakers will be using up all the "casual."

David Beckham

Anthony Mackie

Blazers and Cardigans

These are two top layers that should really be the cornerstone of your office look. In many ways, they're interchangeable. The only thing to keep in mind is that, since a blazer is more formal, it will also be more versatile. With a cardigan, you'll have to make sure the rest of your layers aren't too casual. Stick with a dress shirt underneath and either chinos or trousers rather than jeans.

Jimmi Simpson

Denim at the Office

In today's modern business casual office, denim is totally acceptable. Here's how to pull it off.

Classic
Dark, raw, indigo jeans with a white Oxford, blue blazer, and brogues.

Middle of the Road
Dark indigo jeans with a crew-neck or cardigan sweater, T-shirt, and boots.

Fashion-Forward
Washed denim with a black blazer, white button-down, and black polished shoes.

Jesse Tyler Ferguson

Chris Evans

Freddie Fox

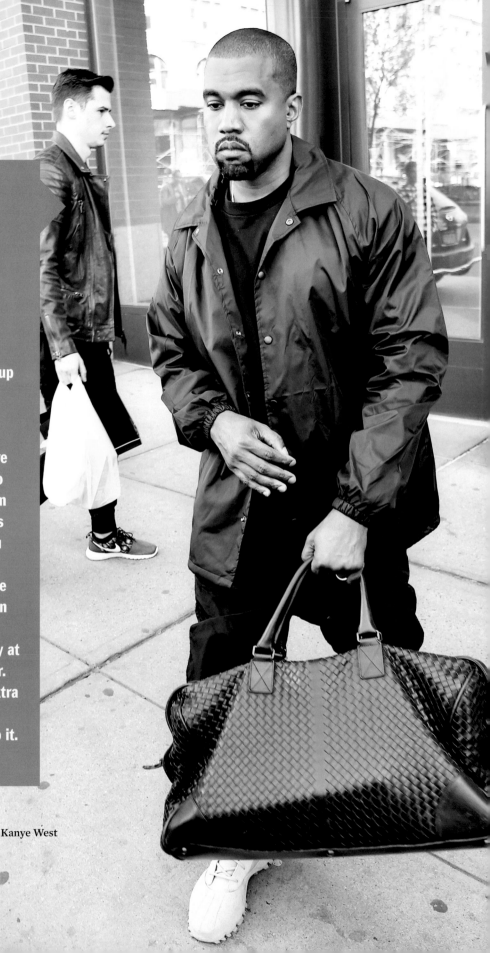

THE CASUAL OFFICE

Thanks in large part to tech start-up culture, casual has become an increasingly common dress code at the office. Show up in anything short of swaddling cloth and you're probably good to go. The upside to this is comfort. The downside is an office that more closely resembles a frat house. But just because you work in a sea of tees and hoodies doesn't mean you can't turn on the style. In fact, considering the often weak sartorial competition, your odds of being the most stylish guy at that office have never been higher. Hopefully this gives you a little extra incentive to improve your casual wardrobe. Here are few ways to do it.

Kanye West

110

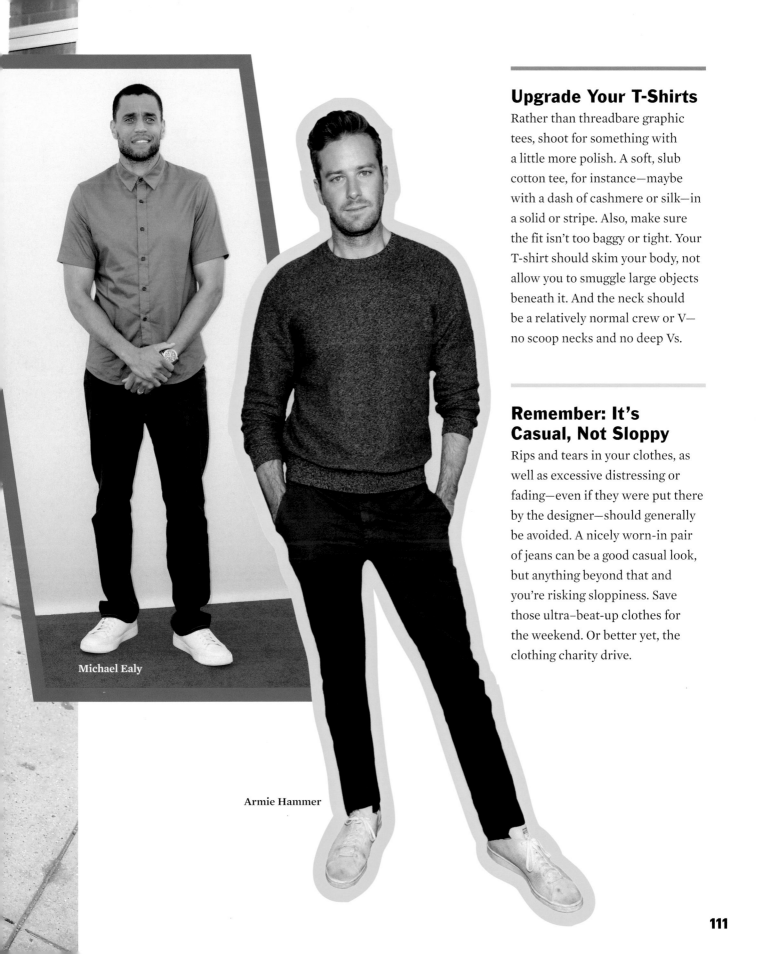

Michael Ealy

Armie Hammer

Upgrade Your T-Shirts

Rather than threadbare graphic tees, shoot for something with a little more polish. A soft, slub cotton tee, for instance—maybe with a dash of cashmere or silk—in a solid or stripe. Also, make sure the fit isn't too baggy or tight. Your T-shirt should skim your body, not allow you to smuggle large objects beneath it. And the neck should be a relatively normal crew or V— no scoop necks and no deep Vs.

Remember: It's Casual, Not Sloppy

Rips and tears in your clothes, as well as excessive distressing or fading—even if they were put there by the designer—should generally be avoided. A nicely worn-in pair of jeans can be a good casual look, but anything beyond that and you're risking sloppiness. Save those ultra–beat-up clothes for the weekend. Or better yet, the clothing charity drive.

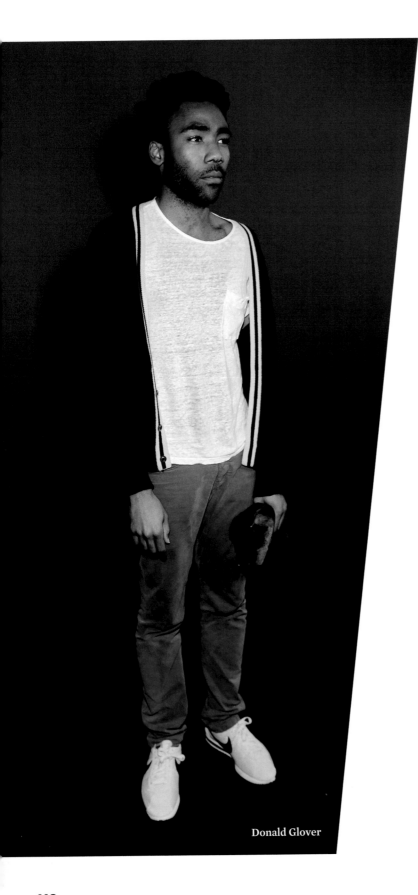

Donald Glover

Layer Up

One way to dress up a casual look is to add a bit of layering. Throw a button-down shirt, unbuttoned, over a T-shirt, for instance. You can also try the same move with a cardigan, or even, during the colder months, a light bomber or Harrington jacket.

Stick to a Slimmer Fit

The thing about casual is this: the baggier you go, the harder it is to look crisp and polished. If you're of the more fashion-forward camp, baggy can work, but it's much trickier to pull off. For the rest of us fashion mortals, it's better to keep things slim—especially with your jeans, chinos, and trousers—to stay sharp.

The Casual Office Sneaker

In this case, the sky's pretty much the limit. But if you want to keep your casual look professional, it's still best to stick to lower profile sneakers with minimal color schemes. Something classic, like the Adidas Stan Smiths or the Converse Chuck Taylor All-Stars, or a more modern style like the Common Projects Achilles or Gucci court shoes, are perfect for just about any casual office setting. And if you want to add a littler character, try a designer sneaker—something from a brand like Gucci, Saint Laurent, or Maison Margiela.

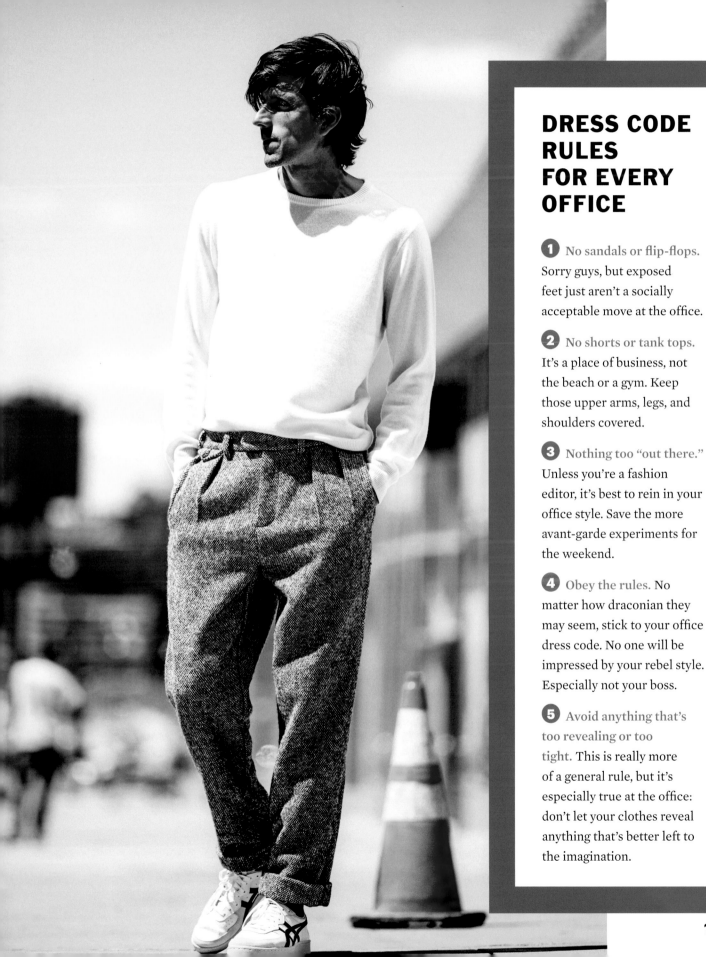

DRESS CODE RULES FOR EVERY OFFICE

1 **No sandals or flip-flops.** Sorry guys, but exposed feet just aren't a socially acceptable move at the office.

2 **No shorts or tank tops.** It's a place of business, not the beach or a gym. Keep those upper arms, legs, and shoulders covered.

3 **Nothing too "out there."** Unless you're a fashion editor, it's best to rein in your office style. Save the more avant-garde experiments for the weekend.

4 **Obey the rules.** No matter how draconian they may seem, stick to your office dress code. No one will be impressed by your rebel style. Especially not your boss.

5 **Avoid anything that's too revealing or too tight.** This is really more of a general rule, but it's especially true at the office: don't let your clothes reveal anything that's better left to the imagination.

HAPPY HOUR

It's no secret that one of the best parts of the working day is when the working day is done. And, of course, the primary institution for ringing in that joyful moment is happy hour. Since happy hour is an event that occurs immediately after work, you're often stuck wearing whatever you wore that day to the office. This is fine if you work in a place that's business casual. But if your daily uniform is a suit, it can get annoying. Especially when happy hour turns into cocktail hour and you're suddenly "That Guy in the Suit." Luckily there's an easy fix for this. All it takes is thinking ahead and a few spare items packed into your bag or briefcase.

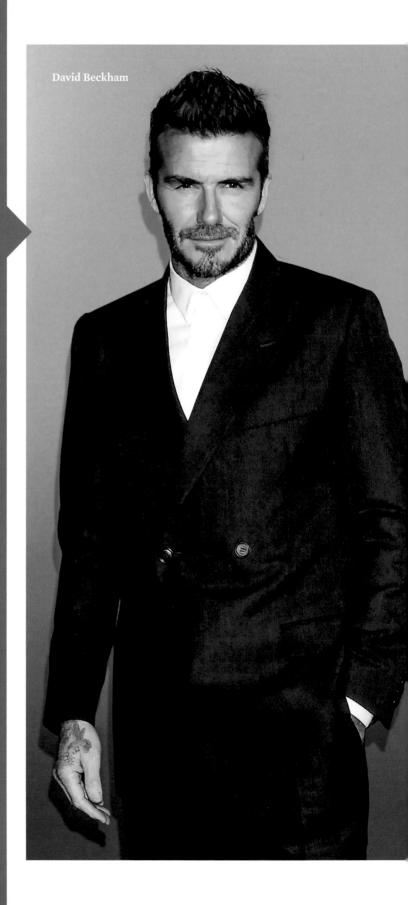

David Beckham

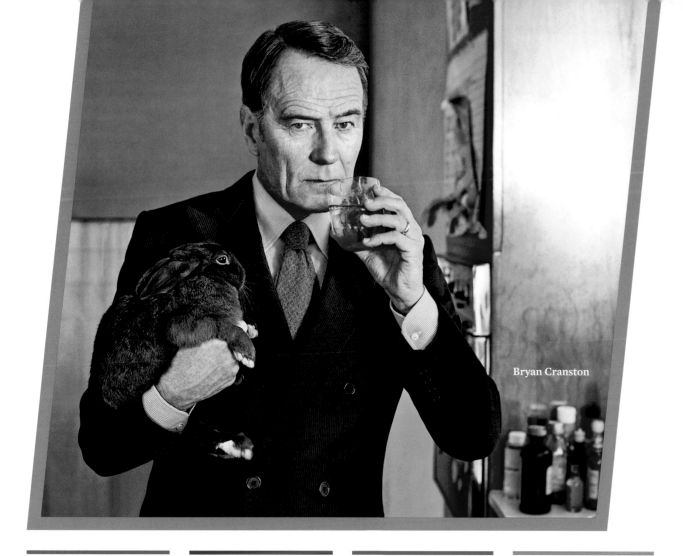

Bryan Cranston

Swap Out Your Dress Shirt for a Stylish Tee

Whether it's a simple white tee or a Breton stripe, this is the easiest way to turn your office look into top-notch cocktail hour style. If you decide to forgo the T-shirt swap, however, at least ditch the tie.

Swap Our Your Dress Shoes for Sneakers or Chelsea Boots

This is a move that can be done with the T-shirt swap or without. For maximum rocker, go with Chelsea boots and a tee. For more polished street style, try minimalist sneakers with the dress shirt sans tie. (You can also keep the top button buttoned, aka the "air tie," with this look.)

Swap the Suit Jacket for a Bomber

This is an easy one, since you can make this switch right out in public. You should also get rid of the tie with this look, and, for bonus points, trade your dress shoes for a stylish pair of sneakers.

Swap the Dress Shirt and Suit Jacket for a Black Crew-neck Sweater

Obviously this one requires a bit more undressing, but it's made up for by the fact that it requires fewer items packed in your briefcase.

A NIGHT ON THE TOWN

THE STYLISH MAN AT HIS BEST

"FASHION has to reflect WHO YOU ARE, WHAT YOU FEEL at that moment, and WHERE YOU ARE GOING."

—PHARRELL WILLIAMS

If you care about style, then dressing up for a night out is basically like Christmas, your birthday, and summer vacation all rolled into one. It's a moment to celebrate and savor because it allows you to clean up, experiment, and have a little fun, at least sartorially speaking. Whether it's cocktails with friends or the big social event of the season, your evening attire is an opportunity to really wow people and show them you're a guy who knows how to put an A+ look together—a look that will get you past any velvet rope. Basically, it's your blank canvas, with your only constraints being sophistication and elegance.

TEN TIPS FOR THE PERFECT NIGHT OUT

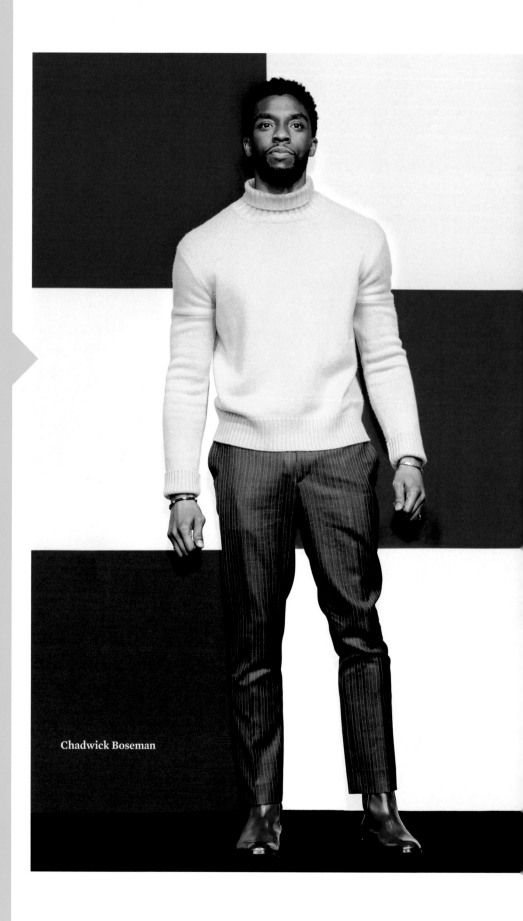

Chadwick Boseman

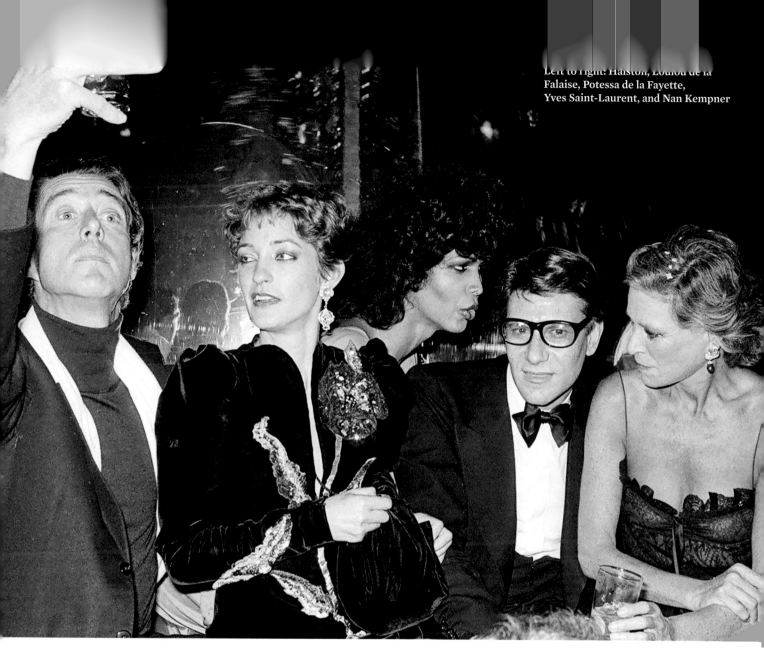

❶

Fit is key.

Okay, fit is always key, but it's especially important when you're dressing up, which is your whole objective for a night out. Make sure that everything you put on—trousers, shirt, jacket, and even your shoes—is tailored to perfection.

❷

Think about comfort.

This isn't the time to wear sweats and running shoes, but you still want to give comfort a nod. Don't choose footwear that's going to hobble you if you have to walk farther than a city block or bother you when you are dancing the night away. You need them to be comfortable enough for a long night out. And, as with your clothes, avoid overdressing for the summer and underdressing for the winter. Excessive sweating or shivering is never a good look.

③ Experiment, but don't overdo it.

However adventurous you get, make sure that elegance and sophistication are still your mantra. It'll keep you from standing out in a bad way. Plus, you don't want to go so over the top that you feel awkward. Just follow the golden rule: "Wear your clothes, don't let your clothes wear you."

④ Less can be more.

Coco Chanel's rule for going out was to always remove one item before you leave the house, and it's a good rule to follow. Here, the idea is to avoid overdoing things with too many layers or too much accessorizing. Sometimes the simplest outfits are the most elegant.

⑤ Add a personal touch.

Whether it's a scarf, colorful socks, or a pocket square, one small item of personalization can often have a big effect on your outfit. You'll be surprised at how many people zero in on it.

Karl Glusman

8
If in doubt, bet on black.

If you're worried about what to wear, go with something black. It's already the official color of going out, especially if you live in the city, and it's an easy way to look sharp (some might even call it cheating) no matter what you're wearing.

6
Road-test your look.

If you want to avoid the dreaded "bad outfit feeling," make sure to always road-test your outfits—that is, wear them around the house—first. Oftentimes, you'll put something on and sprint out of the house, only to find you don't like what you have on but have no way of changing it. If you try it on first at home, you'll be certain that it feels right when you're out and about.

9
Don't stray too far from your comfort zone.

You want to make sure you never wear anything that makes you feel too self-conscious. Sure those ultra-baggy plaid pants might be trendy, but if you feel weird in them, that insecurity will show. A little bit of experimentation is good, but too much, unless you have the confidence to back it up, will make you uncomfortable.

7
Respect the dress code, if there is one.

It might be annoying to have to follow rules when you're out to have fun, but you should always respect the rules of the club, host, or whoever is running the show. You can still have fun within that code; just focus on the smaller details—your shoe choice, a print instead of a white shirt with your suit—to do it.

10
Put it on and forget about it.

Not thinking about what you're wearing is really one of the biggest factors in having great style. It means you're confident. And when you're confident, you can pretty much pull damn near anything off. If you're constantly thinking about what you have on, however, even the most conservative choice can look awkward.

NIGHTTIME STYLE

To really nail a great nighttime look, it's best to stay within the realm of your overall personal style. That's not to say you shouldn't occasionally step outside your comfort zone. It's better to stick with what you know. If you're the guy who's always in something tailored and you suddenly show up in a pair of super-skinny jeans and a leather fringe jacket, your friends might be a little freaked out. This will then likely freak you out, or, at best, leave you spending the night explaining your sudden style swerve. Instead, think of your nighttime style as an extension of your daytime style, only with a bit more polish. Let your personality shine through the clothes you wear. Here are the four primary nighttime style categories that can help point you in the right direction.

Jon Batiste

The Sophisticate

This is for the guy who fancies himself something of a modern-day Rat Packer, with tailoring as a major component of the look—either up top, down below, or all around. Pair tailored wool trousers with a lightweight bomber jacket, or a crisp dark blazer with a pair of dark jeans. And for a hall-of-fame upscale look during the cold weather months, try a thin-knit cashmere or merino turtleneck under your suit or blazer.

Jared Leto

Zayn Malik

The Rebel

Think of this as the grown-up version of rocker style. The fundamentals are denim with a splash of black leather, as well as an occasional piece of fashion-forward tailoring. Slim fit is important here. Slouchy and baggy just won't cut it. Pair a black motorcycle jacket with a bold-print shirt, black jeans, and Chelsea boots. Or maybe a dark blazer with cropped, dark jeans and a graphic or striped T-shirt.

The Prepster

Although prep doesn't always lend itself to nighttime style, there are some definite elements you can work with. You just have to give it a little edge. Like a navy blazer paired with slim black cropped jeans, a white tee, and black leather loafers. Or a crisp pair of tailored dark trousers with a navy crew-neck sweater and minimalist white sneakers. For chillier evenings, you can also throw a navy Harrington jacket—preppy stalwart if ever there was one—on top.

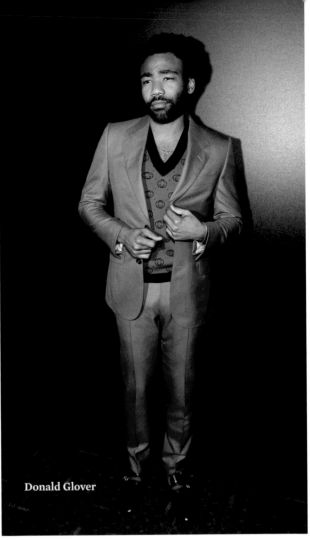

Donald Glover

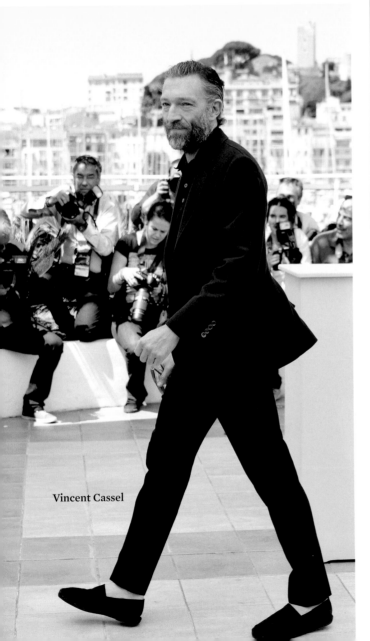

Vincent Cassel

The Laid-Back Sophisticate

This is similar to the traditional sophisticate, only slouchier and a little more bohemian. This is for the guy who knows his whiskey but isn't afraid to switch it up for a top-shelf margarita. A great example of this style would be an unstructured dark linen blazer with looser cropped trousers, a solid tee, and suede leather loafers. Or you can even go with traditional tailoring, but in an unexpected color. It's also okay to combine elements of rebel style, like a black leather jacket with a white button-down shirt, dark looser cut wool trousers, and a pair of elegant black lace-up boots. The important thing is to keep everything a little bit laid-back. Like, yes, you are sophisticated, but you're not a guy who has to try too hard.

Idris Elba

THE POWER OF A BLAZER

When it's time to head out for the night, there are few better or more versatile options than a well-cut blazer. It's such a simple item, and yet it has the power to completely transform your look. Wear a T-shirt, jeans, and sneakers on their own and good luck getting into anywhere other than McDonald's. Throw a crisp, dark blazer over them, however, and watch the velvet ropes come tumbling down. Just keep in mind that there are a few elements to consider when harnessing the power of a blazer.

Lakeith Stanfield

Paul Newman

Jon Bernthal

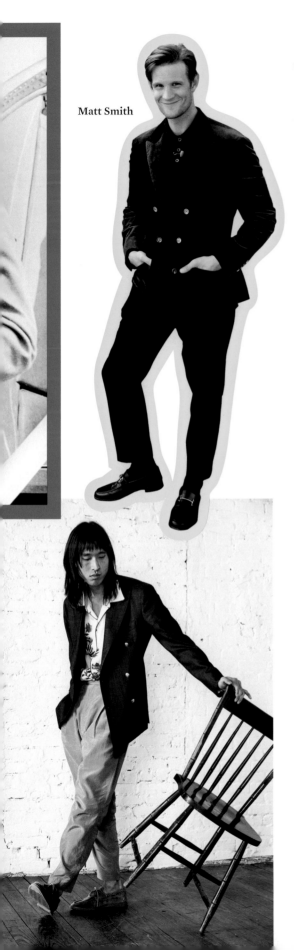

Matt Smith

Consider the Cut

As with any piece of tailoring, fit is crucial. But more than that, it's important to think about the look you're trying to project. If you're going for edgy rocker style, stick with a blazer that's shorter and slimmer and without much structure. A full-blown traditional Savile Row–style cut is too formal and will look out of place when paired with slim black jeans and a T-shirt.

Consider the Fabric

If you're headed to a venue that's relatively upscale—like a nightclub or a formal dinner party—it's probably better to stick with traditional wool. If, however, your venue is a bit more casual—like a house party or drinks with friends—a simple unstructured cotton or linen blazer might be the better call. Obviously, during warmer months, cotton and linen will keep you cooler. But more than that, the unstructured cut with the softer fabric will look polished without being too dressy.

Consider Pattern and Color

Generally speaking, the later it gets at night, the subtler your jacket's pattern should be. And, though this isn't a hard-and-fast rule, the darker the color should be as well. Bold patterns and checks are better for daytime affairs, while subtle pinstripes and checks are more evening-appropriate. And as for color, navy, gray, and black, sure, but also think dark reds, dark greens, and bolder blues.

Consider Double-Breasted

While a single-breasted jacket is a little bit easier to pull off for a lot of guys, a well-cut double-breasted jacket can be a refreshing change of pace. First off, you want to make sure you have the right body shape to wear it—slim with broader shoulders and a narrower waist. Second, make sure it's a nice modern cut—slimmer and a little shorter—rather than the giant, slouchy DBs from the '80s and '90s. And, finally, make sure to always keep it buttoned. An unbuttoned single-breasted blazer can look cool and casual. An unbuttoned DB is too much loose fabric. It will look awkward and unkempt.

DENIM RULES FOR A NIGHT OUT

There was a time when wearing denim for any nighttime event would have been a serious *faux pas*. Fortunately, we live in an age when denim is acceptable for just about anything, even a night at the hottest club in town. That said, there are still a few things to keep in mind when you take your favorite pair of jeans out for an evening spin. Here are the essential denim rules to adhere to once the sun goes down.

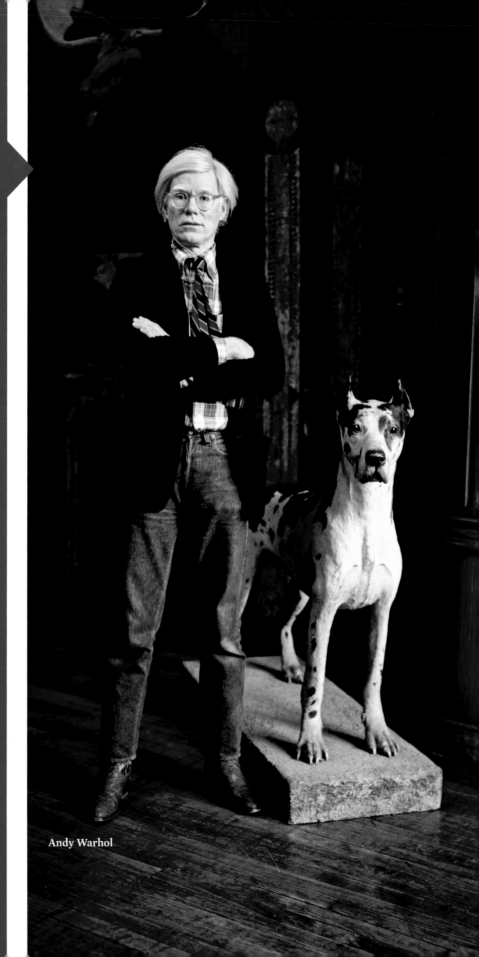

Andy Warhol

Dark Denim Is Best

Save that trusty old pair of beat-up dungarees for a Saturday afternoon. For a night out, go dark—black, indigo, or even gray—as that looks far more sophisticated. Faded jeans run the risk of making you look sloppy, and overly distressed, ripped jeans make you look like you raided a teenager's closet. Neither are ideal.

That Said, Light-Wash Is Possible

If you have the confidence to pull it off, light-wash denim can work. You just have to go high/low with it. And since the faded jeans are low, everything else should be high. Something like a dark, sharply tailored blazer with a crisp white button-down and a pair of polished black loafers to offset the extreme casualness of your jeans. And make sure they look naturally faded, too, rather than faux distressed. Big fake whiskers on the front of your jeans just isn't a good look.

Not Too Skinny, Not Too Wide

If your overall personal style is cool rocker guy, then super-skinny jeans can work. For anyone else, slim is better. It will look more polished and put together and not like you're trying too hard. And baggy is best avoided altogether. While in some cases jeans are moving in that direction, it's more of a casual daytime look. It'll just look too sloppy at night.

Play with Length

Cropped with a little ankle showing, or stacked over a pair of boots—the length of your jeans can go a long way toward determining your overall look. So by all means, experiment and have fun. If you're feeling a bit Continental that night, go cropped. If you prefer a bit of rock 'n' roll edge, go stacked. It's the small nuances that make nighttime style so much fun.

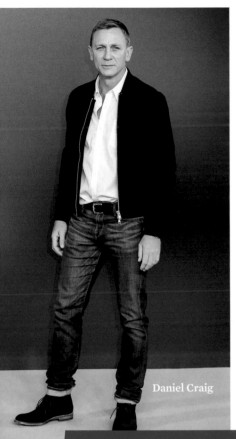

Daniel Craig

Jeff Goldblum

EVENING OUTERWEAR

You've gone to the trouble of putting together a stylish outfit, so why ruin it with some bulky, ugly outerwear? Whether you're dealing with a whiteout blizzard, a light spring shower, or simply a cool, early summer evening, it's important not to let your look fall apart with that final layer. Stick with this can't-miss lineup of coats and jackets to ensure that you stick the landing with your outerwear.

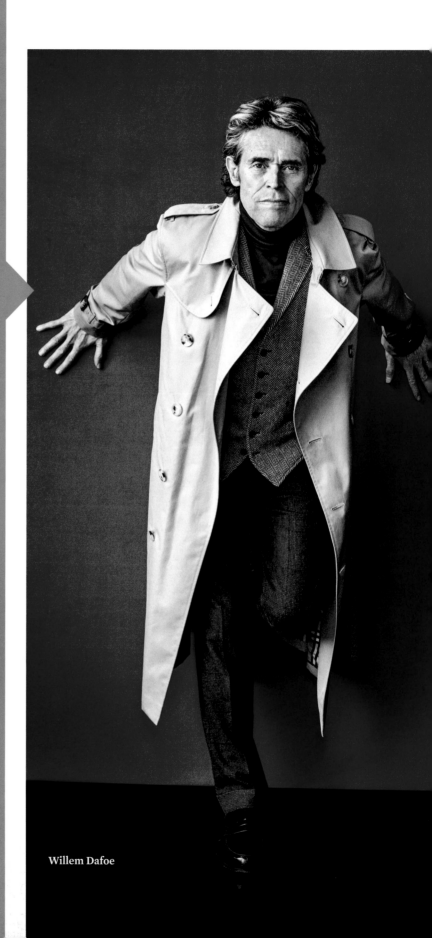

Willem Dafoe

A Wool Coat

For those frigid evenings, you want something thick and long enough that it will ward off the chill, but not so bulky that it looks like you just finished the Iditarod. You want it to be well-tailored and stylish enough to match the elegance of your outfit underneath. Something classic like a top coat, a single or double-breasted overcoat, or even a peacoat is the right move. Extra style points if you choose a camel coat or something with a pattern, like houndstooth.

A Mac or a Trench Coat

Depending on where you live, rain is likely to be the most common meteorological stumbling block to your dapper look. Luckily, a classic mac or trench coat is the antidote to keep you both dry and stylish. Either is a far more elegant response to inclement weather than modern technical jackets, which tend to be too sporty and utilitarian—two adjectives that rarely, if ever, reflect sophistication.

Eddie Redmayne

RAINCOATS 101

The Mackintosh. During the 1820s, Scottish inventor Charles Mackintosh came up with the idea of sandwiching a layer of rubber between two layers of fabric to create a waterproof coat. In 1830, he brought his invention to Thomas Hancock at the Manchester clothing company, and the Mackintosh coat, aka the mac, was born. Knee-length with two or three buttons, today the mac jacket is one of the simplest and most elegant solutions for foul weather.

The trench coat. In 1879, Thomas Burberry, a young draper from Hampshire in England, first developed gabardine—a breathable, weatherproof twill made from lanolin-coated wool yarns. Using this new fabric, the company later created a double-breasted raincoat that became popular with explorers and, eventually, the British military. At the outbreak of World War I, the Burberry gabardine coat became a common choice among British officers, eventually earning the moniker "trench coat," thanks to its popularity in the trenches. Once the war was over, returning veterans continued to use their smart-looking trench coats as civilian wear, making them a wet-weather favorite for well-dressed men everywhere.

A Leather Jacket

Warm enough for a fall evening, but cool enough (figuratively speaking) that you won't want to take it off once you get inside. Whether you go black or brown, or even something more dashing, like oxblood, a leather jacket is a must for any great wardrobe.

A Harrington Jacket

For a light layer that skews a bit conservative, not to mention one that's highly versatile, there is really only one choice: the Harrington jacket. Popular since the 1950s, the Harrington is a simple cotton windbreaker that can add a dash of understated polish to just about any outfit. If you need proof, look no further than James Dean, Steve McQueen, and Arnold Palmer, three cultural icons who were all devoted Harrington fans.

Justin Theroux

A Bomber Jacket

For something light but with a bit more verve than a traditional windbreaker, a bomber is your answer. Based on the U.S. Army's MA-1 flight jacket, the bomber, once primarily the province of punk rockers, has since become an all-around staple for fashionable guys everywhere. Perfect as an extra layer of warmth or as an edgy alternative to a blazer.

A Leather Jacket

Marlon Brando, Indiana Jones, Maverick—three guys who understood the power of a great leather jacket. Add yourself to that list in one of these ways.

Classic

A leather bomber, with or without a shearling collar, is the simplest and most low-key approach.

Middle of the Road

For a little bit of edge but something that's still conservative enough for any guy to pull off, a simple black cafe racer jacket.

Fashion-Forward

It begins and ends with the Perfecto-style moto jacket. Wear it in classic black or get more daring with a bit of color.

Alden Ehrenreich

BLACK TIE

The days of nightly Gilded Age formal affairs may be long behind us, but that doesn't mean a black-tie event won't occasionally pop up on your social calendar. Weddings, New Year's Eve parties, the opening night at the opera— at some point you're going to have to don a tux, and it's imperative that you nail it when you do. A perfectly tailored tuxedo is pretty much the apex of men's style. A shoddy, ill-fitting tux, on the other hand, can make you look like a teenager at his junior prom. Luckily, black tie style is actually a relatively easy thing to pull off. There's a little bit more going on than with a regular suit, and a few extra rules to follow, but as long as you know what you're doing and don't skimp on the tailoring, a pitch-perfect formal look is a cinch. Here's what you need to know.

Riz Ahmed

Eddie Redmayne

Lakeith Stanfield

Henry Golding

Mark Strong

The Jacket

PEAK LAPEL OR SHAWL COLLAR

While a traditional suit jacket will have either a notch or a peak lapel, tuxedo jackets usually only come in peak lapel or shawl collar. The former is where the lapel comes to a peak and points upward at the lapel edge, while the latter has no notch or peak but is simply rounded all along the edge. Technically speaking, a peak lapel is the more traditional, although these days it really doesn't matter. It all just comes down to personal preference. One important detail, though, regardless of which lapel you choose, is that it should be either satin, silk, or grosgrain. It shouldn't be the same fabric as the rest of your jacket.

SINGLE OR DOUBLE-BREASTED

With single- or double-breasted tuxedos, just as with traditional suits, the choice really comes down to body type and personal preference. A double-breasted tuxedo can be a little trickier since, just as with suits, they're a bit limiting in terms of the body type. But one benefit of DBs is that, since there's no chance of your shirt peaking out from the bottom, you don't need a cummerbund or vest. With a single-breasted tux, the only thing to think about is one button or two. Two buttons is the limit, though. Any more than that and you'll commit a major black-tie sin.

THE DINNER JACKET

What the Americans call a tuxedo the Brits call a dinner jacket. The French meanwhile call it *un smoking*. It all amounts to the same thing. Fundamentally, were talking about an evening suit composed of a jacket and pants that don't have to match, but sometimes do. Silk or cotton velvet is a popular choice for the jacket when they don't— best bet is to stick do dark jewel colors.

If you're at an extremely formal even and your host is doctrinaire about the rules , its best to stick with standard black. But since that is unlikely in this day and age, a stylish dinner jacket can be a fun alternative.

The Shirt

THE BIB AND THE PLACKET

The first thing to consider with your shirt is whether you want a bib or no bib. A bib is the panel on the front of the shirt that doubles up the thickness of the fabric. It's technically the more formal choice, and it creates a sharper line, but it isn't absolutely mandatory. If you do choose a shirt with a bib, the next choice is whether or not you want it to be pleated. And if not pleated, then plain or piqué. Piqué is basically just a bib with some texture caused by a dimpled pattern. But don't stress yourself out. It's a personal choice, so just go with what you like (although, we suggest avoiding ruffles all together).

Another element of the shirt to consider is the placket. This is the strip running down the middle. A standard tuxedo shirt can have a placket or no placket. It may have holes so that you can wear it with button studs. Some shirts, however, have a covered placket, which means no studs. For a truly formal, black-tie event, go with the studs. If it's black-tie optional, a covered placket is a-okay.

THE COLLAR

The two main choices here are spread collar—which is like a normal dress shirt collar—or wing tip collar—which has the tips of the collar folded out, like wings. While the wing tip collar used to be the more formal option, today it really doesn't matter. In fact, the spread collar is so common now that the wing tip collar can look a little old-fashioned. However, since the tuxedo has remained virtually unchanged for a hundred years, looking a little old-fashioned is hardly an issue. Listen to your heart on this one.

THE CUFFS

Your choices here are French cuff or barrel cuff. A French cuff is where the cuff is folded back and held in place by cuff links. A barrel cuff has no fold and no cuff links. It is fastened with regular buttons, like a standard dress shirt. If you really want to go formal, choose French cuffs. It's the more elegant option. Plus, it gives you the advantage of adding a little personality with your cuff links. If the dress code is black-tie optional or you just really hate cuff links, then go ahead and choose a barrel cuff.

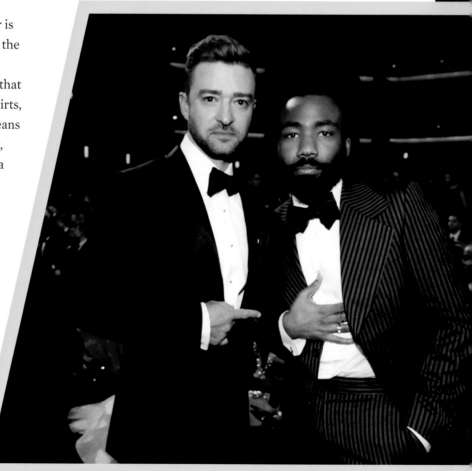

Justin Timberlake and Donald Glover

The Shoes

PATENT LEATHER LACE-UPS

You really have only two footwear choices with a tuxedo, and the first is a patent leather lace-up Oxford. You can get away with a regular polished black Oxford, but, again, if it's truly formal and your host is a stickler, it will be better to opt for patent leather. Also, polished Oxfords tend to indicate that the wearer is a tux renter rather than a tux owner. If you care about those sorts of things, go with patent leather.

VELVET PUMPS

The other appropriate form of black-tie footwear is the velvet pump, also known as an opera pump. This is basically a light velvet slipper in either all black or black with embroidery on the vamp (the upper portion of the shoe). You can also wear a Belgian shoe, which is a light, slipper-like shoe that has a bow on the vamp.

The Tuxedo

1865: Savile Row tailors Henry Poole & Co. fit Prince Edward VII for an ensemble that is more formal than a lounge suit but less formal than tails, because he wants something that he can wear at more informal (though not casual) dinners. It is blue, and he calls it a "dinner jacket" with matching trousers.

1886: The dinner jacket arrives in America, courtesy of an American millionaire named James Brown Potter. He was a friend of Prince Edward, who had convinced him of the dinner jacket's appeal, so he had one made for himself.

1888: James Brown Potter wears his dinner jacket and trousers to the Autumn Ball at a private country club in Tuxedo Park, a wealthy village in upstate New York. His dinner ensemble is so popular that it quickly catches on among the American upper class. At some point during the next decade, it is given the moniker of "tuxedo," which sticks.

1900s: At the dawn of the twentieth century, black becomes the popular choice for the tuxedo and all its accessories. It also becomes the commonly accepted choice for formal dress.

1935: Midnight blue is a popular color for tuxedos, with mills churning out more blue tuxedo wool than black. This is also the time when the double-breasted tux is introduced.

1940s: Due to World War II, the need for austerity causes tuxedos, and formal wear in general, to fall out of favor. Most men just go to formal events in suits.

1960s: Black tie has completely replaced white tie as the top dog of formal wear. In fact, John F. Kennedy is the last US president to wear white tie to the inaugural ball.

1990s: Formal wear hits an all-time low, with neckties becoming acceptable for formal events and single-breasted tuxes coming in three, four, and even more buttons.

2010s: Thanks to the menswear movement, the classic tux is revived, making our current era something of a tuxedo golden age.

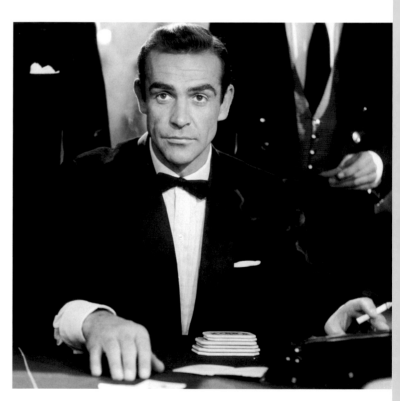

Sir Sean Connery in *Dr. No*, 1962.

The Accessories

CUMMERBUND OR VEST

It's not uncommon these days for men to forgo the cummerbund (that strip of fabric worn around your waist), but traditionally you're supposed to wear one with a single-breasted jacket. Or you can wear a vest. The reason is that there shouldn't be any portion of your shirt exposed below your jacket button, which the cummerbund and the vest both cover up. If you want to do it right, wear a cummerbund in solid black (colored or patterned vests and cummerbunds are best avoided for proper black tie). It'll show people that you're a formal-wear pro.

LINKS AND STUDS

If you do decide to wear a French cuff shirt with stud holes, you're going to need cuff links and shirt studs. The general rule here is to steer toward elegance rather than ostentation. Simple silver or gold, maybe with some pearl inlay or black enamel, is a solid choice. Don't go crazy with giant diamonds or anything like that, and definitely avoid anything kitschy or joke-y. And, if you do go with something metallic, make sure to match the metals of your studs and cuff links—gold with gold, silver with silver.

THE TIE

While men do wear traditional neckties with tuxedos, it's not recommended. It's best to just stick with a traditional black bow tie in satin or a grosgrain neck bow. For an extremely formal event, you're technically supposed to wear a white tie, but then you're also supposed to wear tails (in fact, that dress code is actually called "white tie"), but since that doesn't really exist anymore, just stick with black. And, if you definitely want to impress, make sure it's a self-tied bow tie. With pre-tied bow ties, the bow is too perfect. The slight imperfection of a self-tied bow is actually far more desirable.

THE POCKET SQUARE

If you do decide to wear a pocket square, there is only one acceptable option: white, single-fold silk. All anyone should see is a small, crisp white line emerging from the top of your breast pocket. Save the flair for a more casual event.

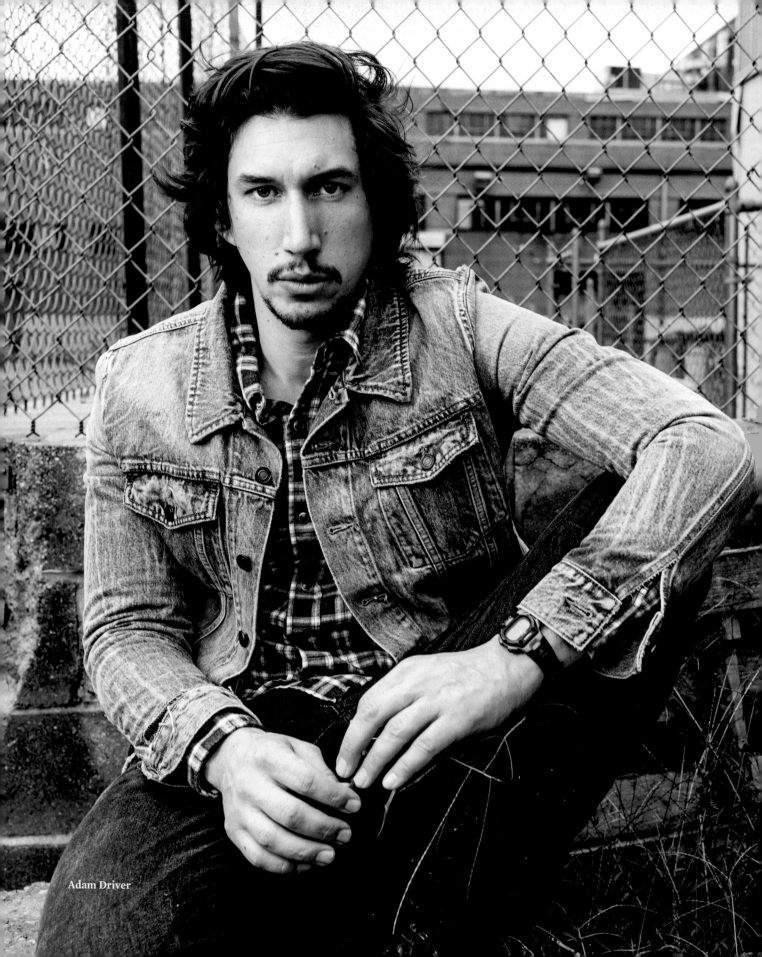

Adam Driver

CASUAL STYLE

LOOK POLISHED, EVEN DURING YOUR OFF HOURS

"The **JOY** of **DRESSING** is an **ART**."
—JOHN GALLIANO

For the truly stylish man, off-duty dressing is nothing more than a chance to show off your sartorial skills without a dress code. Casual and comfortable might be the order of the day, but you still know how to bring a healthy dose of polish. The key to achieving that great off-duty look is to build a foundation of stylish casual essentials—low-key and comfortable pieces that never stray into frumpy territory. And it's also a good idea to stay within the lanes of your own personal style. Other than that, it's simply about having fun and being creative, whether you're having brunch with friends, spending a day in the city, or enjoying a day at the beach.

CASUAL ESSENTIALS

SOME KEY PIECES FOR PUTTING TOGETHER A GREAT OFF-DUTY LOOK

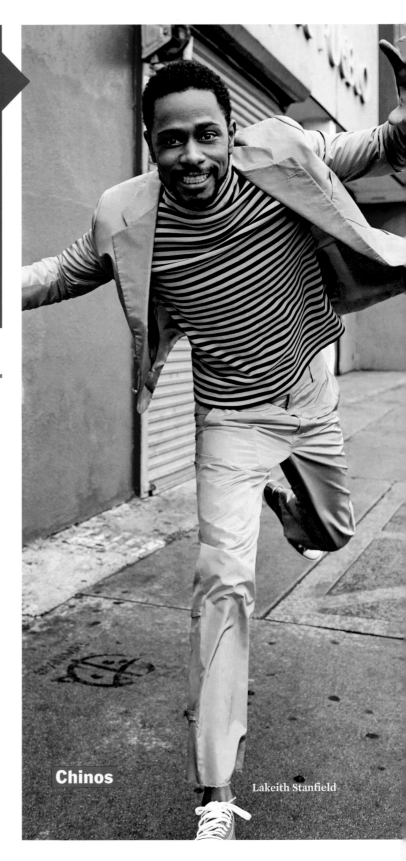

Chinos

Lakeith Stanfield

Layering Pieces

Layering is always a great tool for adding polish to a look, and casual wear is no different. Among the layering stalwarts: tees, button-downs, shirt-jackets, light jackets, or even a casual cotton blazer. Regardless of the season, layering can be a quick and easy move to upgrade your casual style.

Classic Sneakers

While there are many casual options for footwear, the one thing to make sure you always have is a pair of classic sneakers—like Converse Chuck Taylor All-Stars or Adidas Stan Smiths. They're comfortable and will look good in any casual setting. Plus, you can wear them with everything from shorts (or even swim trunks) to jeans to tailored trousers.

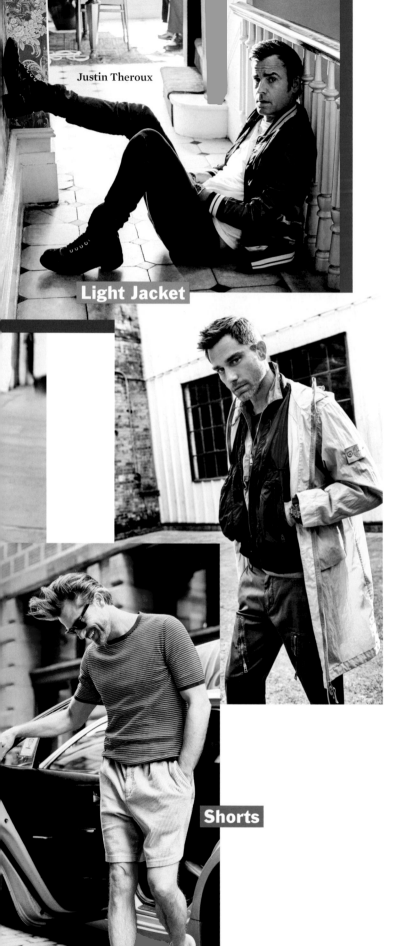

Justin Theroux

Light Jacket

Shorts

Chinos and Jeans

In terms of stylish casual options, there are no better pants than jeans and chinos. They're perfect for just about every off-duty occasion, including lounging around the house. And on top of that, they'll go with anything, which means that you at least have one area of your casual wardrobe that you'll never have to put much thought into.

Shorts

For days at the beach, or even a summer scorcher in the city, a stylish pair of shorts is a must-have. Just make sure they're not too long—the hem should be above the knee—and never baggy. A simple pair of cotton or linen shorts can be dressed up or down, and, most importantly, they will keep you cool when the mercury skyrockets.

A Light Jacket

Whether it's a denim trucker, a bomber, or a windbreaker, it's good to have at least one casual jacket that you can throw on no matter how dressed down you are. It'll come in handy for everything from cool evenings at the beach to crisp fall afternoons in the city.

Fleece and Knitwear

Hoodies, crew sweatshirts, chunky cardigans—it's good to have a range of fleece and knitwear in your casual wardrobe. The pieces should be comfortable but still stylish enough for a weekend afternoon on the town. Not the grubby old college sweatshirt you wear around the house, but not the crisp cashmere sweater you wear at the office, either. You need something that occupies the middle ground.

DRESSING FOR THE WEEKEND

Just as you do at the office and with your evening wear, it's a good idea to keep your casual weekend wardrobe within the confines of your own personal style. That's not to say that you can't experiment. Keep in mind, however, that with comfort as the main objective, you're not going to want something that makes you feel weird or out of place. Apart from that, simply go with what you like and what suits you. Here are some tips for mastering your weekend look.

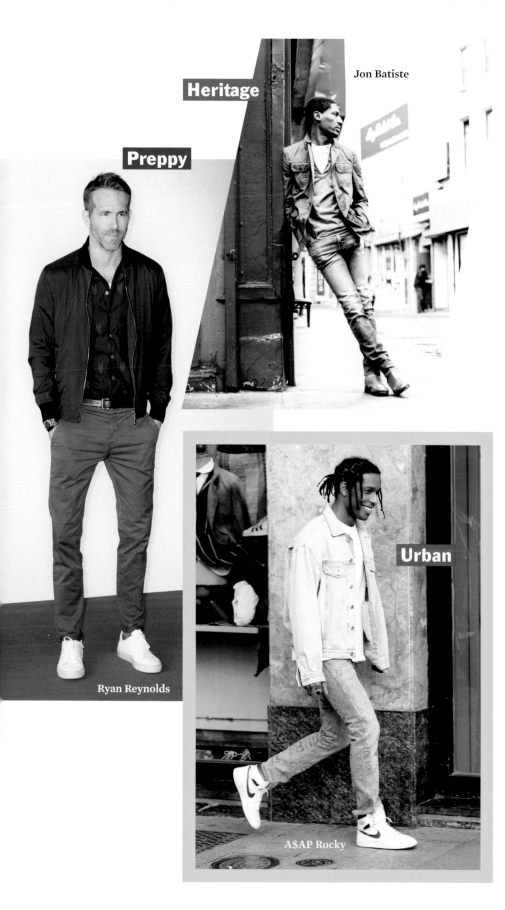

Heritage

Jon Batiste

Preppy

Ryan Reynolds

Urban

A$AP Rocky

Dress Your Age

When it comes to dressing for the weekend, guys often have a tendency to revert to what they wore during their teenage and college years. Sure, baggy shorts and a backwards baseball cap are technically casual, but they'll also make people think you have a Peter Pan complex. Instead, switch to a more age-appropriate ensemble of slim chinos and a solid or striped tee. Or even well-tailored shorts and a solid or striped tee. And never ever wear a backwards baseball cap.

Keep It Simple

This seems obvious—it is the weekend, after all—but sometimes guys can overcook their weekend look. Too much accessorizing, or dressing in a way that's too trendy, can often make your outfit look forced and unnatural. For great weekend style, the simplest outfit is often the best. Like a pair of chinos with a camp collar shirt and some clean white kicks.

Not All Jeans Are Created Equal

A slim-fit pair of naturally faded jeans is a very different animal than super-skinny stretch jeans covered in rips and faux distressing. Both are technically casual, yes, but one is a hallmark of great casual style, while the other is a crime against fashion. Guess which is which. Don't get too creative and experimental with your denim. Stick to the same elements that have made jeans stylish for the last 70 years—a nice, easy fit and a bit of well-worn fading.

Layer for Versatility

Depending on how you're spending your weekend day, it might involve multiple activities over the course of several hours. This means that your look may need to fit multiple style requirements and accommodate varying temperatures. The easiest way to do this is by dressing in layers. A denim jacket or a button-down over a tee with chinos can take you from day to night without the need for an outfit change.

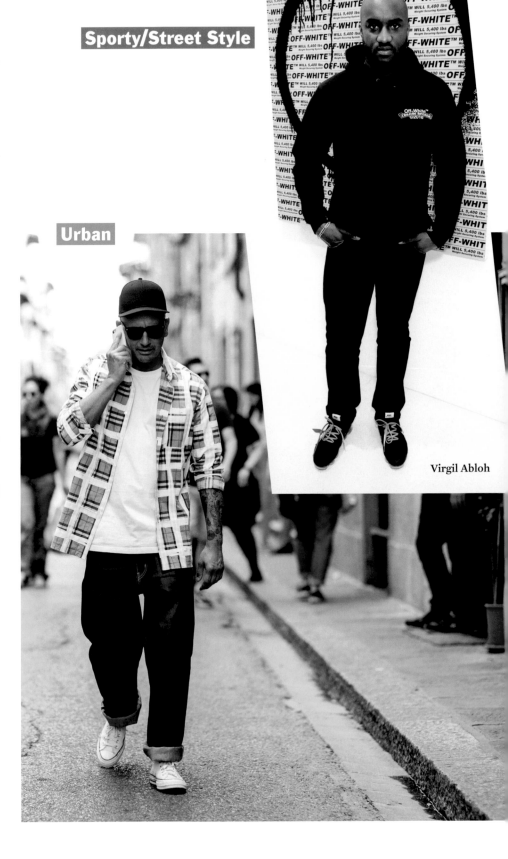

Sporty/Street Style

Urban

Virgil Abloh

Dress for the Airport

Flying is hardly the most comfortable activity these days, but that doesn't justify sweatpants and flip-flops. Here are some tips to upgrade your airport style without sacrificing comfort.

Chinos, not sweatpants.

A soft pair of cotton chinos, especially if they have a bit of stretch added, are plenty comfortable for a long flight. Plus, they have the added benefit of not making you look like you just rolled out of bed.

Layer up.

The temperature on a plane can pretty routinely pinball between Arctic and Saharan. The combination of a T-shirt, a cashmere crew-neck sweater, and a light denim jacket is the stylish antidote.

Yet another strong moment for the blazer.

Want to look good while fending off the chill of a long flight? Try a soft cotton blazer. Perfect for layering, a blazer can also serve you well if you have to head straight to the office or a business casual setting after you land.

Loafers and low-top sneakers.

Loafers are great for getting through security quickly, while a simple pair of low-top sneakers will be more comfortable. It's your choice as to what matters more to you, but either is a good call for the airport.

Harry Styles

CASUAL PANTS

Without pants, we'd not only have a hard time being stylish, we'd have a hard time leaving the house. This means that it's a fairly important part of your outfit to get right. Fortunately, when it comes to casual style on the bottom half of your body, there aren't a ton of rules to follow—just a few low-key guidelines to help you on your way.

Worn-In Is Okay, Grungy Isn't

There are few pieces of clothing better than worn-in jeans or a perfectly broken-in pair of chinos. Just keep in mind, *worn-in* and *broken-in* are not the same as *tattered* and *dirty*. Your casual pants should look clean and lived-in, not like you just fished them out of a dumpster.

Embrace Stretch

Not long ago, you could spot a pair of stretch jeans from a mile away. Fabric technology has made some serious strides in recent years, and now stretch can be added to just about anything, with no one the wiser. So embrace the stretch. They'll look just as crisp and polished, but they'll be more comfortable.

Chinos

Chris Hemsworth

Jeans

Jon Bernthal

Play with Length

This is one area where you can definitely experiment. Showing a little ankle, or even a lot of ankle, can add personality to an otherwise humdrum pair of chinos or jeans. On the other hand, if you've got a cool pair of high-tops to show off, stacking—where your pants are longer so that the hem bunches up over your shoes—might be the answer. With something as simple as the length of your pants, you can completely transform your look. So have fun with it.

Take the Weather into Account

A pair of heavyweight, fourteen-ounce selvedge denim jeans is probably not going to be a fun thing to wear during a hot and humid summer day. Just the same, light linen trousers, no matter how stylish, will not be pleasant during the winter. And since comfort is a key element of casual wear, you'll want to make sure that your pants are working with, and not against, the weather.

LeBron James

Jeans

Ryan Reynolds

Casual Trousers

Blue Jeans

18th Century: In Nimes, France, locals try to replicate a sturdy indigo-dyed sail cloth called *toile de genes*, which they call *serge de Nimes*. While technically not denim, the fabric was similar, and this was likely the genesis of the name—de-Nime.

1873: Bavarian immigrant Levi Strauss and his partner Jacob Davis obtain a patent for their new workpants in San Francisco. Made from denim, they also have metal rivets on stress points, for strength. The first pair of blue jeans (originally called "waist overalls") is born.

1940s: After World War II, American G.I.s occupying Japan sell their old blue jeans on the black market, making vintage Levi's so popular they quickly become a staple of Japanese fashion. Eventually, once supplies of vintage Levi's run low, Japan begins producing its own high-quality denim, creating an industry that's still going strong today.

1950s: In the United States, shuttle looms are replaced by much faster and much more efficient jet looms for denim manufacturing. Though this ends the era of selvedge denim, it makes mass production of high-quality denim possible, opening the door for blue jeans to become a ubiquitous workwear staple.

1953: Marlon Brando popularizes blue jeans in the film *The Wild One*. This cinematic influence becomes even bigger two years later, when James Dean turns blue jeans into a cultural icon, courtesy of the film *Rebel Without a Cause.*

1960s: Thanks to counterculture types, blue jeans become a staple of anti-establishment, "flower power" fashion. During 1967's Summer of Love in San Francisco, blue jeans hit their stride as a major player in the cultural revolution.

Late 1970s: Calvin Klein creates the first "designer" jeans, launching a trend that would become a hallmark of 1980s fashion. Most famously, he releases a controversial 1980 ad campaign featuring a fifteen-year-old Brooke Shields saying, "What gets between me and my Calvins? Nothing."

2010s: Thanks to the heritage movement of late '00s menswear, old-school selvedge denim jeans become popular again. Though more expensive, they are valued for their durability and patina. Even Levi's begins reproducing classic jeans from its past, under the banner of Levi's Vintage Clothing.

CASUAL SHIRTS

When it comes to casual shirts, there is no shortage of options. Whether it's a tee, an Oxford, a camp collar, or a polo, your shirt has the power to really make your outfit, even when not that much of it is showing. The important thing is to make sure that, whatever you're wearing, it fits the right way. Other than that, follow these guidelines to make sure the casual style on the top half of your body is always on point.

Joe Biden

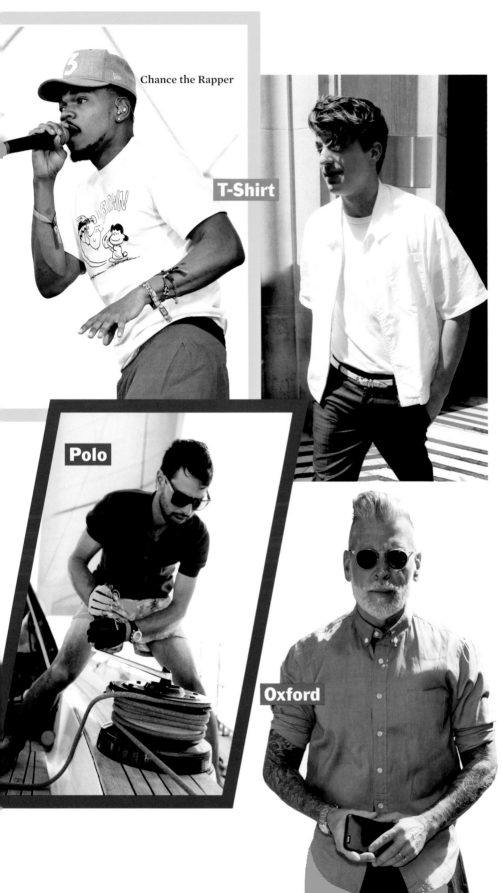

Chance the Rapper

T-Shirt

Polo

Oxford

Nick Wooster

Untuck, but Only if It's Meant to Be

Polo shirts, camp collar shirts, and, to some degree, T-shirts are all designed to be worn untucked; and that's how you should wear them. If you do tuck them in, specifically polos and camp collars, they'll just keep coming out of your waistband, which won't look good at all. If, on the other hand, a shirt is designed to be tucked, don't wear it untucked. It'll be too long and it'll end up looking like some sort of shirt/tunic hybrid. When it's something like an Oxford that can work either way, just make sure that if it's untucked it isn't too long. Again, you want to avoid the whole shirt/tunic thing. And, of course, there is the somewhat controversial move of tucking just the front of the shirt in and letting the rest hang out (sometimes called the "French tuck"). There is no hard-and-fast rule for or against this, so go with your heart. Although, keep in mind that people probably will make comments about it.

153

The Art of Buttoning

If you're wearing a button-down shirt, a good general rule is never to unbutton it below your sternum, unless you have a T-shirt underneath, of course. Someone like Tom Ford can pull off the whole unbuttoned-to-the-navel thing, but he's Tom Ford. Mere mortals should not try it. Another move that can be quite stylish is to button your shirt all the way to the top button, aka the "air tie." Don't try it if it's a shirt that's meant to be open collar. But with a traditional button-down or polo, especially when worn as a base layer under a jacket or suit, it can look pretty sharp.

Layer with Skill

Layering a button-down shirt over a tee can be a great look; you just want to make sure the tee you're wearing isn't longer than the shirt that's over it. Rather than looking artful, it'll just look like you don't know how to buy clothes that fit. And when it comes to mixing patterns, by all means, have at it. A good rule of thumb is to pair a subtler pattern with a bolder one, although that's not set in stone. Basically, just use your discretion. If you like it, go with it.

Have Fun

A shirt—be it a T-shirt, a polo, a band collar, or a regular collared shirt—is one area where you can break out of your comfort zone a bit. It's less intrusive than a jacket or a suit, so feel free to experiment with colors and patterns. This is especially true with a camp collar shirt, which is meant to be a little bolder. Don't be afraid to go a little overboard; you can always dial it down with another layer on top— a jacket or a blazer—that's more subdued.

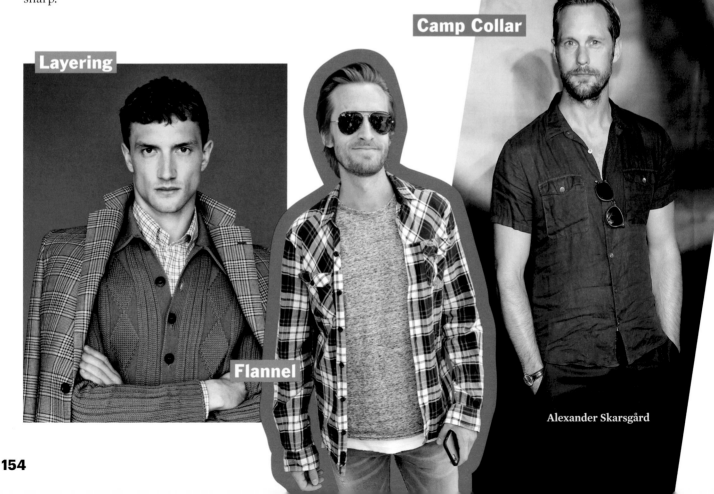

Layering

Flannel

Camp Collar

Alexander Skarsgård

Dress for the Beach

A day at the beach may not mean much in the way of clothing, but a limited palette doesn't mean you can't express yourself. From swim trunks to footwear to sunglasses, here's how to look stylish when you're frolicking in the surf, sun, and sand.

Swim trunks.

Whether you choose board shorts or traditional trunks, find something with a crisp, clean fit. Avoid anything baggy. It'll look bad dry and even worse wet.

Shorts.

Swim trunks will do the bulk of the sartorial work for a beach day, but you still want a pair of light cotton or linen shorts to get you there and back. Especially back, since your trunks may still be damp.

Flip flops/ espadrilles.

The beach is pretty much the one place where flip-flops are universally acceptable, if not downright recommended. For a slightly more stylish option, though, try a pair of canvas espadrilles.

A tank top.

Just as with flip-flops, the beach is one of the few places where a tank top is okay. Keep it dialed down, though—maybe a striped pattern or a solid pastel. Nothing you'd see at a frat party during spring break.

A light sweatshirt.

Occasionally, it can get a little chilly at the beach, especially at night. A crew-neck sweatshirt can shield you from the chill. Just make sure it's lightweight.

Grace Kelly and Cary Grant in *To Catch a Thief*, 1955.

CASUAL KNITWEAR AND FLEECE

The casual workhorses of those chillier days are fleece and knitwear. On blustery days, few things are more comfortable than a thick, cozy cardigan or a classic crew-neck sweatshirt. Fortunately, the casual approach to both is relatively easy. Mostly it's just about making sure everything is in good condition and fits properly. That being said, here are some things to consider when you reach into your closet for that casual sweater.

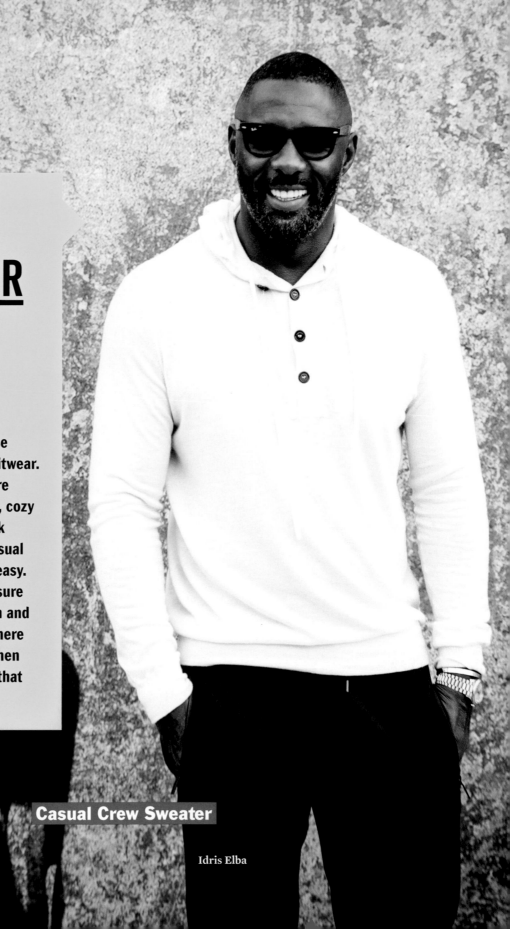

Casual Crew Sweater

Idris Elba

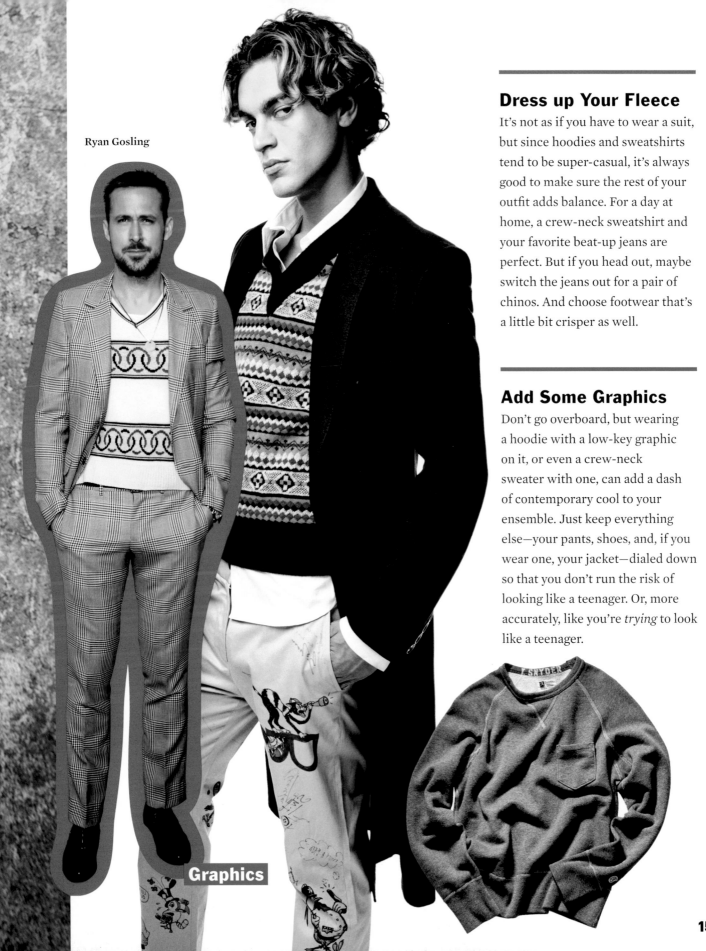

Ryan Gosling

Graphics

Dress up Your Fleece

It's not as if you have to wear a suit, but since hoodies and sweatshirts tend to be super-casual, it's always good to make sure the rest of your outfit adds balance. For a day at home, a crew-neck sweatshirt and your favorite beat-up jeans are perfect. But if you head out, maybe switch the jeans out for a pair of chinos. And choose footwear that's a little bit crisper as well.

Add Some Graphics

Don't go overboard, but wearing a hoodie with a low-key graphic on it, or even a crew-neck sweater with one, can add a dash of contemporary cool to your ensemble. Just keep everything else—your pants, shoes, and, if you wear one, your jacket—dialed down so that you don't run the risk of looking like a teenager. Or, more accurately, like you're *trying* to look like a teenager.

Cardigan

Pharrell Williams

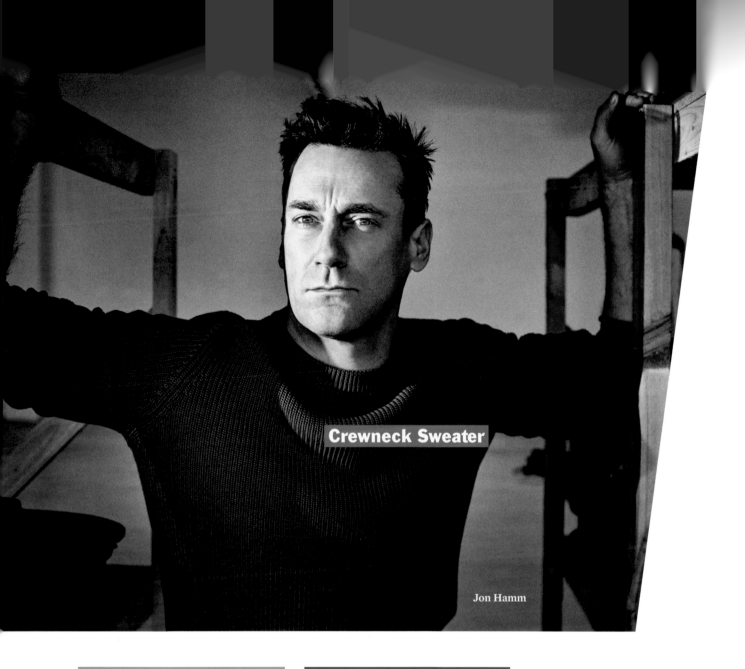

Crewneck Sweater

Jon Hamm

Embrace the Classics

There is a reason that classic knitwear and sweatshirts have been around forever—they're timeless. A chunky cardigan and a simple heather gray crew-neck sweatshirt—they looked good on your grandfather and they'll look good on you.

Focus on the Material

Whether it's a French terry sweatshirt or a mohair cardigan, you can't beat quality material. This is especially true in this realm, as the whole idea of it is to keep you warm and cozy. It'll be more expensive to choose higher-quality fabric, but it'll last a lot longer, feel better, and you'll wear it a lot more often.

CASUAL SHOES

With any great outfit, shoes really are the cornerstone. And since casual footwear covers a pretty wide spectrum of styles, you have a lot of opportunity to play with your look. Think of it this way: a pair of jeans and a T-shirt with some Chuck Taylors will give you one look, and those same jeans and T-shirt with a pair of black lace-up combat boots will be entirely different. Same outfit, different shoes, totally different vibe. The moral of the story: it's important to put some thought into your footwear. Here's what to consider when you do.

Mick Jagger and Bianca Rosa Perez-Mora marry in St. Tropez, 1971.

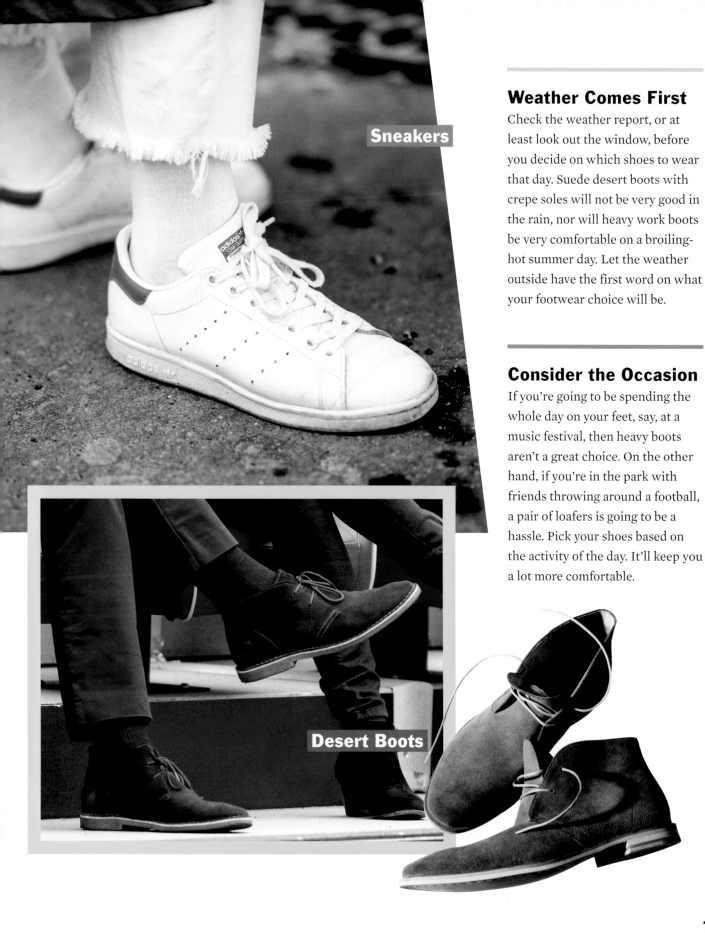

Sneakers

Desert Boots

Weather Comes First

Check the weather report, or at least look out the window, before you decide on which shoes to wear that day. Suede desert boots with crepe soles will not be very good in the rain, nor will heavy work boots be very comfortable on a broiling-hot summer day. Let the weather outside have the first word on what your footwear choice will be.

Consider the Occasion

If you're going to be spending the whole day on your feet, say, at a music festival, then heavy boots aren't a great choice. On the other hand, if you're in the park with friends throwing around a football, a pair of loafers is going to be a hassle. Pick your shoes based on the activity of the day. It'll keep you a lot more comfortable.

Pair Your Footwear with the Right Outfit

If you're going for a summer look with white chinos and a Breton tee, a pair of chunky basketball sneakers or combat boots is not going to enhance that look. Low-top sneakers, on the other hand, or maybe some espadrilles, absolutely will. Think of your outfit as a whole, and then make your shoe choice accordingly.

Show Your Personality

Shoes, especially for guys, is one area where you get to show off some personality and flair. We don't have as many clothing options at our disposal as women do, so shoes is where we can really shine. Boots, loafers, sneakers—whatever you're feeling that day, go ahead and allow it to tell the biggest part of your sartorial story.

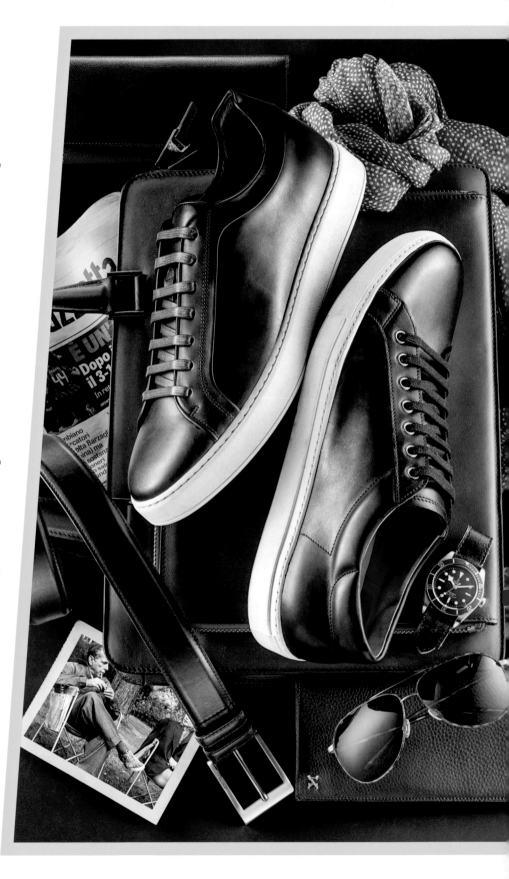

Shia LaBeouf

CASUAL OUTERWEAR

The great thing about cooler, or even colder, weather, is that it allows for the possibility of layers. And layers mean that you can be a whole lot more creative with your outfit. This is where the strength of casual jackets comes in. They offer a wider variety of silhouettes than suits or blazers can, which means that you can really play with texture. Plus, they just look cool. Here are some tips to raise the level of your casual outerwear game.

Shia LaBeouf

Field Jacket

Warmth Comes First

While you don't want to skimp on style, it's still important to make sure that the jacket you're wearing is warm enough. A denim trucker looks cool, but if it's the middle of winter and it's the only jacket you have on, you're going to be miserable no matter how great you look. Plus, your face should never be as blue as your denim.

Milo Ventimiglia

Go for a Well-Worn Look

Most classic casual jackets look better when they're a bit worn-in. Whether it's a field jacket, a waxed cotton jacket, or a trucker, your casual outerwear should look like it's had some adventures and seen some life. If you start to hear the word *patina* in reference to your jacket, you know you're doing something right.

Denim Trucker

Robert Redford and Lauren Hutton in *Little Fauss and Big Halsy*, 1970.

Nick Wooster

165

Waxed Cotton

Drake

Performance Jacket

Traditional Versus Modern Materials

There's no right or wrong answer when it comes to traditional as opposed to modern materials. A waxed cotton jacket made from something more technically advanced than actual waxed cotton may keep you warmer and drier. But then again, an old-school cotton field jacket is going to end up with a patina that you can't often duplicate with a human-made fiber. Mostly it just comes down to personal preference. Do you prefer utility or patina?

Layer Up

Obviously, a casual jacket is a great layering piece on top of your shirt or sweater. But don't be afraid to layer multiple jackets as well. A denim trucker with a waxed cotton jacket over it can be a very dapper look. So, too, can a peacoat over a field jacket. Just make sure the bottom layer is a little lighter than the others, and then experiment away. It will open up a whole new realm of visual texture.

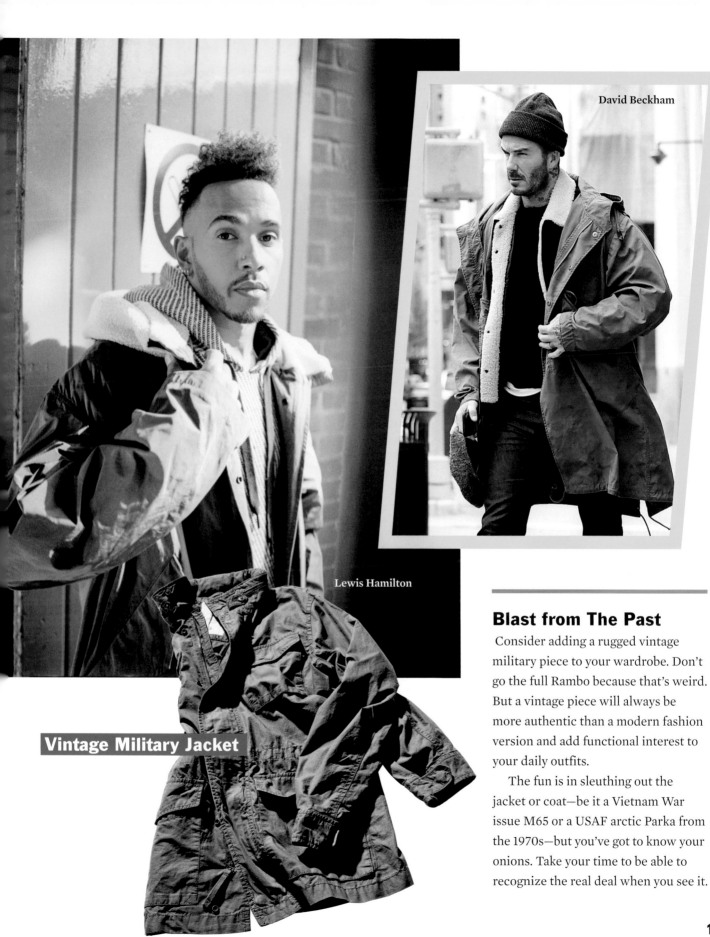

David Beckham

Lewis Hamilton

Vintage Military Jacket

Blast from The Past

Consider adding a rugged vintage military piece to your wardrobe. Don't go the full Rambo because that's weird. But a vintage piece will always be more authentic than a modern fashion version and add functional interest to your daily outfits.

The fun is in sleuthing out the jacket or coat—be it a Vietnam War issue M65 or a USAF arctic Parka from the 1970s—but you've got to know your onions. Take your time to be able to recognize the real deal when you see it.

167

Bryan Cranston

WORKOUT GEAR, UNDERWEAR, AND ACCESSORIES

YOU'VE GOT YOUR WARDROBE SORTED, NOW IT'S TIME TO FOCUS ON THE EXTRAS

"Make it **SIMPLE**, but **SIGNIFICANT**."

—DON DRAPER

Great style shouldn't stop with the clothes on your back; it should permeate every facet of your wardrobe. From what you wear alongside your clothes, to what you wear underneath your clothes, even to what you wear when you work out (in order to fit into your clothes). Style is a holistic enterprise, and you want to make sure you're covering it from every angle. Of course, when it comes to underwear, workout gear, and accessories, style is only one part of the equation. You also want to make sure you're maximizing utility. Because, in this regard, looking good is just half the battle. From the right socks to the right luggage to the right gym sneakers, here is everything you need to know to have a fully fleshed-out wardrobe.

WHAT TO WEAR TO THE GYM

That beat-up old college T-shirt may work well enough at the gym, but it certainly isn't what anyone would call stylish. Plus, given the impressive array of fabric technology available these days, you're not exactly doing yourself any favors in the performance department, either. It's time to upgrade your workout attire. Here are a few tips on how to get the most out of your workout wardrobe.

Chris Hemsworth

Get Technical

In the old days, some light cotton was all you needed. Today, however, there are fabrics that can cool you down, warm you up, and keep you dry—sometimes all at the same time. Think about what kind of workout you're going to do, and then look for fabrics designed for that particular exercise regimen. Whether you need compression, sweat wicking, or anti-chafing—or all of the above—there's a fabric out there that can handle your routine.

Think Beyond the Running Sneaker

Running shoes are obviously the ideal choice for running. But if you're just hitting the weight room, you really should wear something that offers a bit more stability—like a basketball shoe. To maximize your performance, always choose a sneaker that's custom-made for your specific workout. Whether you want lightweight and shock-absorbing, or stable and comfortable, the options are out there. Plus, if you happen to be sneaker-obsessed, it gives you one more excuse to show off a cool pair of kicks.

Dress for the Conditions

In a controlled environment, like the gym, a shirt, shorts, and sneakers are all you really need. But if you head outdoors, say, for a run or a bike ride, you want to make sure that whatever you're wearing can handle the elements. If it's blisteringly hot out, wear something light and cool. If it's cold or raining, or even snowing, you want layers that will keep you warm enough to keep moving, but they should also be breathable so that you don't get overheated. And you'll also want something that's good for wicking away sweat. Sweating and chilly temperatures are a bad combo for both comfort and health. Just make sure that, whatever the conditions, you're properly attired. That way you won't be tempted to cut your workout short.

Think About Before and After

Changing in the locker room before and after your workout can be a hassle. Luckily, there are plenty of stylish clothing options out there that look just as good on the street as they do in the gym. This means you can wear the same set of clothes for both your workout and the juice you grab afterward with a friend.

WHAT TO WEAR UNDERNEATH

You've gone to all the trouble of building a perfect wardrobe for every facet of your life, so why stop at what's underneath? Would you remodel a house on the outside but leave it dingy and shabby on the inside? Granted, not as many people will see below the top layer, but, at the very least, you will. So why not make it the best it can be? Plus, what you wear underneath can have real consequences for what you look like on the outside. It can influence the contours of your waist and silhouette, how you walk and sit, and, thanks to modern fabrics, how much you sweat. Here are some tips to make sure you get everything right, even for what's between your clothes and your birthday suit.

Different Body Type, Different Underwear

Maybe you've worn the same type of underwear all your life. Or maybe you've made the journey from briefs, to boxers, to boxer briefs. However you've landed on your current version of underwear, hopefully body type and lifestyle factored into your choice. If they didn't, they should have. Do you have super-skinny legs? If you do, briefs are better, since anything else will bunch up around your thighs. Do you have super-thick hockey player thighs? If you're the desk-bound type, boxers might be okay. But if you're active, you'll want something with more flexibility, like boxer briefs. Don't just assume you have the right underwear because it's what you've always worn. Give multiple styles a spin and see which one is the most comfortable.

Pierce Brosnan in *The Matador*, 2005.

Play with Colors

Say you're the guy who wears a colorful pocket square. Or maybe you love a bold-patterned blazer. Shoot, maybe your entire wardrobe is a Mardi Gras of color. Why, then, would you wear boring old black, white, or gray underwear? Even if you're the only person who sees it, adding personality to what lies beneath your clothes is totally worth it (unless you're wearing white pants, of course. For that, stick with white or light gray so they don't show through). Subconsciously, you'll know that you look great at every layer, which will add to your confidence and will positively affect the image of you that others see.

Let Your Socks Tell a Story

Even if you're a minimalist in your wardrobe, your socks can be a great place to break out and show a little more personality. Since they're not all that visible, unless you're sitting, of course, they won't be intrusive, even if you go for a bold pattern or color. And a pop of color can add visual texture to an outfit, which will create an overall sense of elevated style. It's the small details, after all, that truly make the stylish man. Let your socks be one of those details.

Or Try No Socks at All

Revealing a bit of bare ankle with a cropped trouser can be an excellent warm-weather move. It shows a certain devil-may-care insouciance that can be very appealing. The downside is, without socks, you can funk up a pair of shoes pretty quickly. Fortunately, we live in the age of the no-show sock. These are socks that can be worn with any low-top shoe or loafer but won't show above the topline— meaning that all people will see is bare ankle. It's all the fun of going sock-less, with none of the stench.

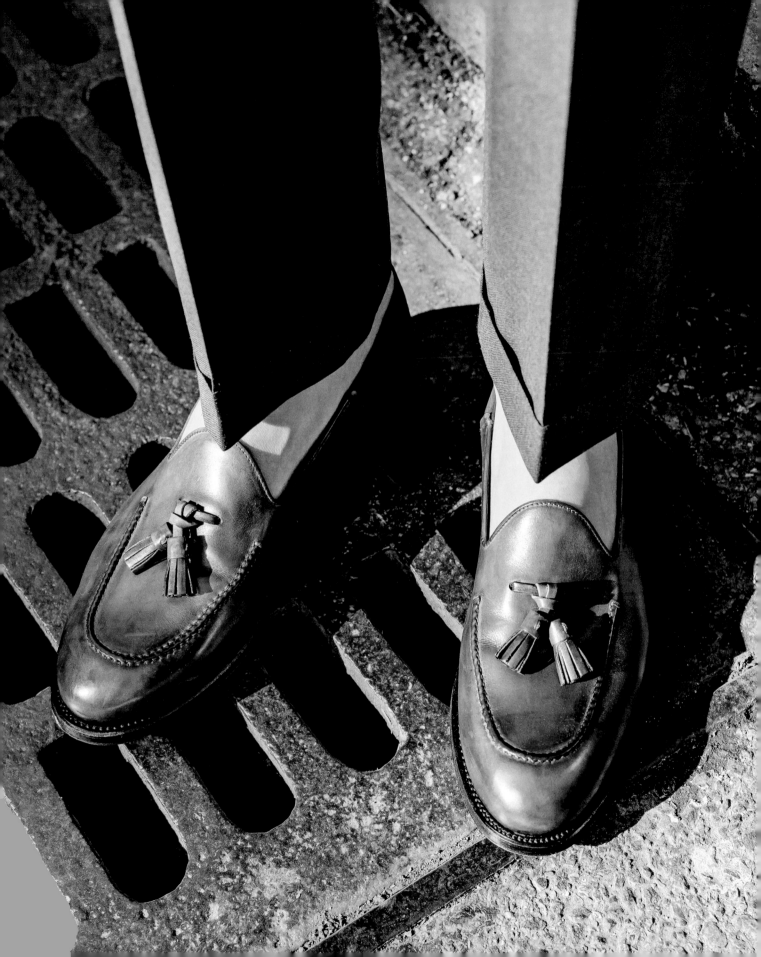

BAGS AND LUGGAGE

There are few images more jarring than a stylish man in a well-tailored suit—crisp tie, polished wing tips, dapper pocket square—carrying a backpack. It's like seeing a Porsche with a bike rack on top. Avoid committing this cardinal style sin by upgrading your workbag. And while you're at it, you should also upgrade your luggage. Whether you're carrying a laptop to the office or half your wardrobe on a trip around the world, it's important to have a sophisticated bag to do it in.

Travel in Style

When you're young and traveling, any bag big enough to carry your clothes will do. But as you get older, you should upgrade to proper luggage. That means a nice weekender bag in canvas or leather for shorter trips and a hard-shell roller case for anything longer. Most hard-shell roller cases come in sizes that meet all airline requirements, so you can pick up a carry-on as well as a regular suitcase. And while it's good to get something stylish, the important thing is to find a case that's durable and that maximizes space. You want your suitcase to withstand the worst of those baggage carousels, and you want your carry-on to withstand the flight attendant cramming it into the overhead compartment.

Ditch the Ziploc

Yes, a Ziploc bag will get the job done when it comes to hauling your toiletries, but wouldn't it be nice to try something a bit more elegant? A stylish Dopp kit in canvas or leather, or even in nylon, not only looks better, it also works better. Besides the separate compartments to accommodate your various ablutionary needs, it's also designed for easy access while brushing your teeth or shaving. This means that, unlike a Ziploc, it won't disgorge the entire contents of your bag the moment you set it down on the bathroom counter.

A Grown-Up Workbag

When you're in your early twenties working at an entry-level job, carrying a backpack isn't a big deal. But once you get a promotion, it's time to start thinking about a briefcase, attaché case, or even a stylish messenger bag. You can start with something canvas so that you don't break the bank. But as your income increases, consider upgrading to something with leather. There's an elegance to a great leather workbag that's hard to find with anything else. And, as most bags nowadays have specific compartments for laptops, you won't need to go for one of those painfully uncool black neoprene tech bags.

WATCHES, JEWELRY, ODDS AND ENDS

And now we get down to that final dash of sartorial flavor. Small accessories won't necessarily make or break an outfit, but they can certainly elevate your look as long as wear them well. And, as with everything else we've talked about, what you wear in terms of watches, jewelry, belts, and gloves should fall within the scope of your personal style. If you tend to dress conservatively, a garish watch with a whole bunch of crazy bracelets and necklaces might be jarring. That said, don't be afraid to play around with these accessories and have some fun. Here's how to make sure you get the smallest details of your wardrobe right.

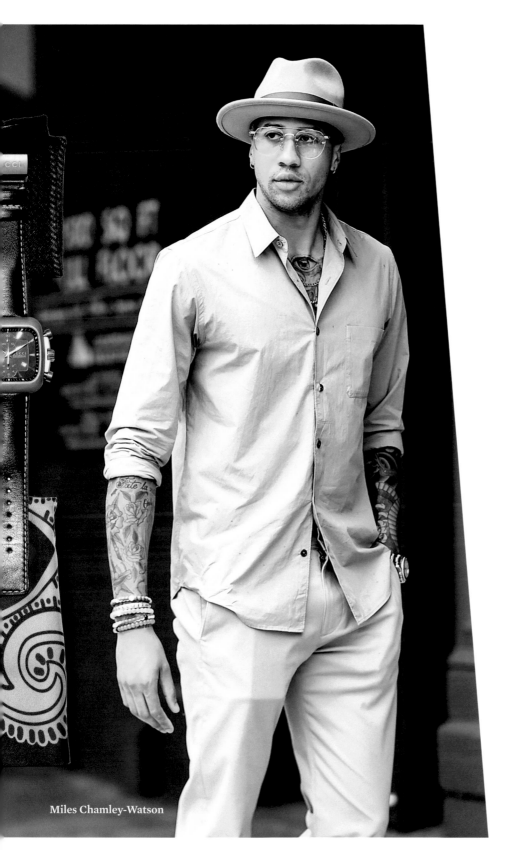

Miles Chamley-Watson

Less Is More

Whether you're a minimalist or a maximalist, doing more with less is always a good philosophy. Even for a maximalist, there will be a tipping point where it's clear you've gone too far. There is no set rule for what qualifies as "too far"; it really just comes down to your own discretion. A hand full of rings and an arm full of bracelets might be right for one guy, but total overkill for someone else. A good way to judge is to pay attention to what people focus on. If you find that they only ever mention your accessories, it's a good sign that it might be time to tone it down.

Be Creative

Fred Astaire famously used to wear colorful neckties as belts. This just goes to prove that creativity can be a real asset when it comes to style. Maybe you're not up to the necktie-as-belt approach, but don't be afraid to try new things when it comes to your accessories. Maybe a bold-colored canvas D-ring belt rather than standard brown leather. Or maybe a small bandanna around your wrist rather than a silver bracelet. You'll never know whether you like something until you try it. And that something may turn out to be the style that you become famous for.

Stay Slim

Wallets are pretty handy for carrying your money and all, but they can get pretty thick and unruly fast. If you're a diehard wallet guy, that's fine. But if you'd like to take some of the weight out of your pockets (which, considering the phones we carry around, is not a bad thing), think about switching to a credit card case or even a money clip. They'll keep your pockets organized, with the added benefit of not creating a giant bulge. A nice, clean line is especially important with tailored trousers, and a card case or money clip is the best way to achieve it.

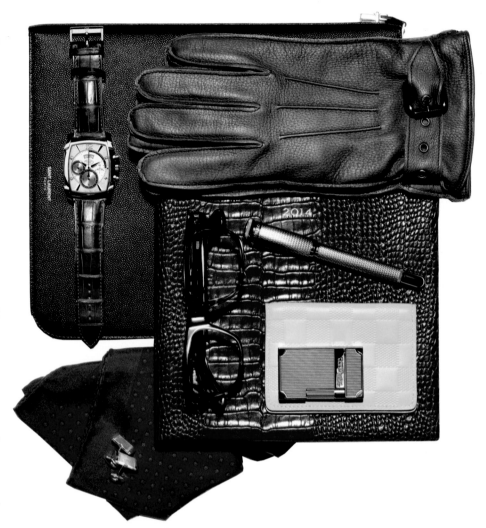

Buy the Best You Can Afford

Whether it's a watch or a pair of leather winter gloves, the best approach is to always buy the best you can afford. Poor quality can really stand out with smaller accessories. A cheap, poorly made watch will be evident from a mile away, while a quality one will look good from any distance. That's not to say that you should spend *more* than you can afford to get something nice. After all, there are plenty of quality items in every price range. This is especially true for items that have any sort of utility, likes watches or gloves. If your watch doesn't keep good time and your gloves don't keep your hands warm, then what's the point?

THE
LAST
WORD

The final takeaway is not really about fashion, or what to buy, or what's appropriate. It's about inspiring you to find the real you. The saying shouldn't be "dress to impress." It should be "dress to feel like the best version of yourself." Because it doesn't matter what other people think; it matters what you think. If you like what you're wearing, you feel confident in it, and you feel that you can do or accomplish anything by wearing it, then that's worth much more than the price of admission. Clothes don't make the man, but they can certainly help tell his story. So, go forth and be stylish.

PHOTO CREDITS

Gotham/GC Images: 87 left; GP Images/WireImage: 157 left; Steve Granits/WireImage: 102 right; GVK/Bauer-Griffin/GC Images: 69 left, 170; Alexander Hassenstein for Porsche: 67 top left; Estate of Evelyn Hofer: 128; Dave J Hogan: 81 bottom right, 109 right; Hulton-Deutsch Collection/Corbis: 33; Nicholas Hunt for Tribeca Film Festival: 54; Amir Hussein: 73 top; Samir Hussein/WireImage: 57 top right, 156; Melodie Jeng: 40 middle, 166 top; Josiah Kamau/BuzzFoto: 110, 167 top right; Robert Kamau/GC Images: 150 bottom; Dmitrios Kambouris: 71 bottom, 154 right; Stefanie Keenan for Rolling Stone: 112; Keystone-France/Gamma-Keystone: 126 top right; Barry King: 100; Jon Kopaloff/FilmMagic: 79 top middle; Jeff Kravitz/FilmMagic: 60 middle; 108 top right, 134 top right; Franziska Krug: 63 bottom left; Jean-Baptiste Lacroix/AFP: 73 bottom; John Lamparski: 88 left; Claudio Lavenia: 31 bottom; Jason LaVeris/FilmMagic: 15 right; Pascal Le Segretain: 52 left, 63 top left, 131 left; Patrick Lichfield/Conde Nast: 28; David Livingston: 139; Michael Loccisano: 53; Dan MacMedan: 51 right; Fabrizio Maltese/Contour: 48; Mike Marsland/WireImage: 83 left; Emma McIntyre for Esquire: 60 left; Michael Ochs Archives: 16 bottom right; Mark Milan/GC Images: 38 middle right, 71 top left; Gjon Mili: 87 right; Ethan Miller: 109 middle; Gary Miller/FilmMagic: 165 middle; Martin Mills: 79 bottom; Neil Mockford/GC Images: 153 top right; Tim Mosenfelder: 79 top left; Sonia Moskowitz: 119; Max Mumby/Indigo: 161 bottom left; Han Myung-Gu/WireImage: 165 left; Han Myung-Gu for Disney: 118; Cindy Ord: 89, 174 right; Cindy Ord for Sheen Center: 93 top right; Albert L. Ortega: 91 middle, 134 bottom right; Bertrand Rindoff Petroff: 88; Petroff/Dufour: 108 top left; Marc Piasecki/GC Images: 58; Marc Piasecki/WireImage: 132 left; Pictorial Parade/Archive Photos: 93 top left; Christopher Polk: 123 middle; Christopher Polk/NBC/NBCU Photo Bank: 136; Mike Pont/FilmMagic: 93 bottom right; Jacopo Raule: 38 left middle, 102 left; Sebastian Reuter/WireImage: 145 middle; George Rinhart/Corbis: 155 bottom left; Roy Rochlin/FilmMagic: 91 left; Alberto E. Rodriguez/WireImage: 109 left; Robino Salvatore/GC Images: 145 bottom; Rebecca Sapp for SBIFF: 79 top right; Jun Sato/GC Images: 129 bottom, 147; Jun Sato/WireImage: 69 right, 114; Steve Schapiro: 165 right; Scott Serio/Eclipse Sportswire: 158; Randall Slavin for Contour: 49 left; SMXRF/Star Max/GC Images: 49 top right; Clint Spaulding: 40 right; Astrid Stawiarz: 150 right; Ray Tamarra/GC Images: 40 left; Karwai Tang: 27 left; Michael Tullberg: 106 bottom; Noel Vasquez: 127 top; Venturelli: 85 right; Venturelli for Gucci: 81 top right; Christian Vierig: 30 top, 31 top, 34 left middle and middle right, 35 left and right, 146 bottom; Ricky Vigil/GC Images: 166 bottom; Slaven Vlasic for Sports Illustrated: 59 top middle; Theo Wargo/NYFW – The Shows: 91 right; JP Yim for NYFW - The Shows: 17 left; Daniel Zuchnik: 179

© **David Goldman photographs of Jon Batiste for Esquire Magazine:** 122, 145 top

Ben Goldstein/Studio D: 2 top middle and middle center, 3 middle left, 14 bottom left, 19 left, 20 top; 21, 23 bottom, 52 right, 65left middle, 65 right, 104 top, 155 bottom right, 157 right, back cover bottom right

© **Beau Grealy photographs of Jon Bernthal for Esquire Magazine:** 2 middle left, 106 top, 126 bottom, 149; **photographs of Lakeith Stanfield for Esquire Magazine:** 103 bottom, 126 top left, 142

© **Christopher Griffith:** 150 top left, 161 top right, 167 bottom

© **Alexei Hay photograph of Pedro Pascal for Esquire Magazine:** 103 top; 26, 29, 32 back cover top right

© **Andrew Hetherington/Redux Pictures:** 81 bottom left

HEARSTBOOKS

An Imprint of Sterling Publishing Co., Inc.
1166 Avenue of the Americas
New York, NY 10036

HEARST BOOKS and ESQUIRE are registered
trademarks and the distinctive Hearst Books logo
is a trademark of Hearst Magazine Media, Inc.

© 2019 Hearst Magazine Media, Inc.

ISBN 978-1-61837-282-6

Distributed in Canada by Sterling Publishing Co., Inc.
c/o Canadian Manda Group, 664 Annette Street
Toronto, Ontario M6S 2C8, Canada
Distributed in the United Kingdom by GMC Distribution Services
Castle Place, 166 High Street, Lewes, East Sussex BN7 1XU, England
Distributed in Australia by NewSouth Books
University of New South Wales, Sydney, NSW 2052, Australia

For information about custom editions, special sales, and
premium and corporate purchases, please contact Sterling Special
Sales at 800-805-5489 or specialsales@sterlingpublishing.com.

Manufactured in China

2 4 6 8 10 9 7 5 3 1

sterlingpublishing.com
esquire.com

Cover design by Elizabeth Lindy
Interior design by Ashley Tucker
Photography credits on page 184